We Art Women

We Art Together

「存在·她力量」──國際女性當代藝術

Existence · Her power - International Female Contemporary Art

總策展人：張朱宇

策展總監：楊宜瑄

學術主持：戴士和

學術支持：陶詠白、佟玉潔、賈方舟、楊　衛

藝術總監：王守清、周　晉、陳偉邦

特邀策展：黃　梅、郭　楨、韓　祺、洪　欣

聯合策展：趙文靈、朱文玉、源淑芳、徐　冰、Sandra Angliss、Adela Holmes

Chief Curator : Cissy Cheung

Curatorial Director : Rochelle Yang

Academic Director : Dai Shihe

Academic Supporters : Tao Yongbai, Tong Yujie, Jia Fangzhou, Yang Wei

Art Directors : Wong Sau Ching, Zhou Jin, Clement Chan

Specially Invited Curators : Huang Mei , Guo Zhen, Han Qi, Hong Xin

Joint Curators : Zhao Wenling, Zhu Wenyu, Yuan Sook Fong, Xu Bing, Sandra Angliss, Adela Holmes

藝術無界
大美無價
大愛無疆

Unbounded Art

Priceless Beauty

Infinite Love

CONTENTS 目錄

CIRCLE OF LIFE:
ECOPOETIC

生生不息：
大地與城市的生態詩學

SHAPING MENTAL IMAGE:
FABRIC AND ASSEMBLAGE

塑造心像：
織物與裝配藝術

ODE TO A NEW ERA: IMAGINARY DIALOGUE
THROUGH TIME AND SPACE

新時代頌：
穿越時空的影像對話

I-DART:
SPECIAL ART

愛而不同：
特殊展能藝術

AN AFTERWORD BY CHIEF CURATOR

總策展人語

ANOTHER EXISTENCE
別樣的存在

Professor of Central Academy of Fine Arts
Dai Shihe

中央美術學院教授
戴士和

The meaning of "Existence" is more than its literal meaning, it conveys that women have their own unique, different and distinctive strength. In the world of art, women's strength, in one perspective can be recognize as charisma and attractiveness.

Sometimes by looking at an art work, one can tell at once whether this work was done by a female or not. However, what sets its boundary? The signal is rather mysterious and cannot be explained by words. For example, the prints created by Kathe Kollwitz and Li Qingzhao, the most well-known female poet in Song Dynasty. Her poem "Summer Quatrains" reads, "Man lives to be a hero, wants to be a hero of the ghost even after death." One can be surprised that this poem was written by a woman poet.

To clarify all these is not easy. One can find that such power is abstract to comprehend, however this power is eminence, and extraordinary which can neither be replaced nor be diminished. With this power of women, the world is made perfect and rich.

I very much admire Dr. Cissy Cheung who has endless endeavor, persistence and hard working. She organizes different art exhibitions and seminars in various aspects and directions, giving this title, women power, a very interesting and profound meaning.

「存在」這個名字有意思。 不僅是說她的存在意義，而且是說她有她自己的、不同的力量的存在方式。在藝術天地，這股力量更多體現為她的魅力、吸引力。

女性作品有特別的魅力。一幅繪畫的作者是否女性，有時單看作品也能隱約猜出幾分。但那界線究竟何在？又很神秘，未必說得清整。比方珂勒惠支（Kathe Kollwitz）的版畫，比方「生當作人傑，死亦為鬼雄，至今思項羽，不肯過江東」的作者，怎麼就女性了？

說清楚並不容易，但是這股「她力量」的「存在」，確實能量很大、很特別，她的存在不可能被別的力量所取代、不可能被化約掉。她存在，天地才完整，才豐厚。

我佩服張朱宇博士的雄心和多年堅持的努力，以藝術作品展覽理論研討的多種方式，給這個古老的命題貢獻出饒有興味的新解。

THE EXISTENCE OF CONTEMPORARY MUSE

"Existence·Her power" Curatorial Director

Dr. Rochelle Yang

Muse is the Goddess who inspires artists' creativity in Greek mythology. For centuries, women have existed in the halls of art, where they are mostly neglected. A question once raised in a well-known article by art historian Linda Nochlin in the 1970s, "Why are there no great female artists?" addressed the issue. Noklin pointed that the social norm under the dominance of patriarchy made it difficult for a "great female artist" to develop her career. Noklin helped people to understand that it was not that there was an artistic male style or aesthetic that was privileged over some sort of feminine style, but that women had been kept out of the academy, and hence away from art production and the art market itself.

The female artists so called muses had long become like the silent gypsy nomadic people in the art world, their existence had been unsustainable like the sporadic flash in the pan. Throughout the history of art, most of the masters who promoted the art movement were men, for example, Michelangelo and Da Vinci in the Renaissance, Matisse in the Fauvism, Dali in the surrealism, Monet in the impressionism, and Andy Warhol in Pop art, etc.

It is not difficult to understand that talented women in the twentieth century or earlier, they would be inevitably influenced by the social values of the male dominate society and became caregivers in the family and society, making them unable to invest more effort in the artistic career. For early women, making art was more of a personal interest rather than the goal that should be fought for in a lifetime, becoming a great artist seems to fit to the male ideal. Naturally, the mentality of willing to be invisible or secondary makes women's talents ignored by the society. Consequently, the quantity and price of female's artworks in exhibitions are still significantly behind that of men in the mainstream art market.

This issue has been frequently discussed in art market analysis in the past. Even in the era of equality between men and women as today, the art market inevitably depreciates the existential value of female artists' creation due to the stereotypical impression. Art agents or investors believe that the middle-aged male artists are at their prime, whereas they have different view on female artists who might give up easily due to domestic reasons or social pressure. As a result, agents are unwilling to invest more resources in curating exhibitions and promoting ephemeralartists.

Fortunately, in a "society in which all women shine" in the digital age of the 21st century as today, women receive no less resources and support than men in terms of educational opportunities and media channels. In the art schools and universities nowadays, the proportion of women in the classroom often far exceeds that of men. This phenomenon manifests that more women have devoted in artistic creation, and women's art has received unprecedented attention in recent years.

According to a study by Sotheby's study in major auctions in November 2019, Female artists continue to realize accelerating price growth, exceeding that of male artists. Subsequently, the auction company and art agents have begun to invest and promote the works of contemporary female artists. The leading auction house Philips released the result at the contemporary art auction in Hong Kong in 2022, 90% of the works of female artists exceeded the estimated price surprisingly. The triumph was significant for it set a historical record that female artists shine in auction. Based on the Art Basel art market survey, in the first season of 2022, five out of the top ten artworks in turnover, the female artists were all born after 1980. The survey manifests that young female artists in their thirties are more growth-oriented in the current art market than male artists of the same generation. It is unprecedented for female artists to achieve such an important status in the auction market.

The theme "Existence - Her Power" of the International Female Contemporary Art Exhibition resonated with the rise of female art. The Art Life Foundation pioneers in setting up an international platform so that more contemporary women's creativity can be seen. "Existence" refers to existentialism emphasizing the transcendence of women's "immanence" and realize her self-value. Female's artworks ought to be valued for the artwork itself rather than the gender stereotype, just like the American artist Georgia O'Keeffe who once positioned herself as "I am a painter, not a female painter".

At last, we whole heartedly congratulate the prominent progress of female art and look forward to the better future when female art keeps progressing without borders and beyond gender stereotypes.

當代繆斯的「存在」

「存在·她力量」策展總監

楊宜瑄博士

給予藝術家靈感的女神常被稱為繆斯，繆斯是希臘神話中的藝術與青春之神，是女性獨特的創造力。幾個世紀以來，女性其實一直存在於藝術的殿堂中，然而卻大多不被重視。

縱觀藝術史，推動藝術浪潮派別的大師們絕大多數都是男性，從文藝復興時期米開朗基羅或達文西、野獸派的馬諦斯，到超現實派的達利、印象派的莫內、普普藝術的安迪沃何等，人才輩出。

《為什麼沒有偉大的女性藝術家？》（*Why Have There Been No Great Women Artists？*），研究女性藝術的歷史學家琳達·諾克林（Linda Nochlin）於上個世紀 70 年代提出了以上研究觀點，諾克林注意到男權主導之下的社會情境，使得「偉大的女性藝術家」幾乎難以成立。繆斯女神們，早已成為藝術界中緘默的吉普賽遊牧民族，縱使有零星的曇花一現，也依舊難以持續。

其實不難理解，早期的女性即便才華洋溢，也會受到由男性架構的社會價值觀所影響，在家庭、社會中成為照顧者的角色，令其在藝術事業上無法投入更多的心力或者退而求其次，將創作當作興趣，而非一輩子應該奮鬥的目標。甘於附庸的心態，令女性的才華被忽略或是光芒被隱藏。成為偉大的藝術家的夢想似乎是更屬於男性的理想，對女性而言也太過沉重和遙遠。

即便在男女平等、社會風氣開放的現今，藝術市場也不可避免地忽略女性藝術家的存在價值。主流藝術市場上，女性藝術家參展數量和作品價格大幅落後於男性，這正是過去女性主義藝術，以及藝術市場分析中經常被討論的議題。市場對於男女藝術家資源的傾斜也存在偏向。經紀人或者投資者認為四五十歲是男性藝術家爬坡的巔峰，而對於同年齡段的女性藝術家則不免擔憂其可能因為照料家庭而中斷藝術的創作，或者產量減少，再不然認為可能是玩票性質的副業而不願意投注更多的資源培養。所以，整體的產業對於女性藝術家長期以來有著刻板的印象——並非去正視創作作品本身，更在乎背後的女性身份所帶來的種種考量。

幸運的是，在 21 世紀的數位時代，不論在教育機會以及媒體管道上，女性所得到的資源和支持不亞於男性，大學高等學府的藝術文化相關科系，教室裡的女性比例甚至經常遠遠超過男性。這意味著已經有更多的女性投入藝術創作，女性藝術也受到前所未有的重視。

根據一項最新研究顯示，自蘇富比 2019 年 11 月多場大拍女性及非裔美國藝術家表現尤其亮眼後，拍賣公司銷售策略佈局開始推廣當代女性藝術家的作品。收藏家和各大機構也有計畫地推廣女性創作的藝術。富藝斯（Philiips）在 2022 年香港現當代藝術拍賣中發布，「90% 的女性藝術家作品超出了高預估價」。也目睹到第一次藝術拍賣史上，女性藝術家創造了最多的拍賣成交金額。根據巴塞爾（Art Basel）藝術市場調查，在 2022 上半年成交額前十名當中，有半數女性藝術家皆是 1980 年後出生，可見三十多歲的年輕女性藝術家相較同世代的男性藝術家更具成長性。如果以前 50 名來看，則有 21 名是女性藝術家，女性藝術家在拍賣市場上取得如此重要性的局面，是前所未有的！

女性藝術在疫情之下的表現令人雀躍。有人說，或許是女性作品中特有的柔美細膩，安撫了疫情之下人們的心靈。毋庸置疑的是，女性藝術家們正在崛起，無論在虛擬和實體的藝術空間，都綻放著她們的光彩和創造力。

2023 年 3 月即將在中環香港大會堂所舉辦的「存在·她力量——國際女性當代藝術展，大會主題「存在」可謂意義深遠。天趣藝術人生慈善基金會率先搭起國際平台，令更多的當代女性創思能夠被看見。「存在」同時也意味著存在主義之於女性主義，強調對女性「內在性」的超越，企圖擺脫「他者」和「他性」狀態，使女性主體意識得以鮮明，使女性成為一個自由的主體，實現自身的價值。尤其是透過純粹的藝術作品而被看到價值，超越性別的框架。

如同美國藝術家歐姬芙（Georgia O'Keeffe）在 20 世紀初期那女性藝術家寥寥無幾的保守年代，曾經如此定位自己「我是畫家，不是女畫家」。我們仍然期待當代的潮流繼續朝向藝術無國界，真正超越性別的「存在」。

念兹在兹：
致敬她力量

ETERNAL MEMORY: SALUTE TO HER POWER

FANG ZHAOLING

方召麐

YUEN CHEE LING

源子玲

ART CASTED THE FOUNDATION OF WOMEN'S SELF-RELIANCE

Article / Simiao Ma, Baishi Weng, Haohua Cai, Haoshuang Wu, Qirui Wei, Chia-hsin Ke

From the start of the 20th century, a domestic aesthetic education movement began to emerge. Cai Yuanpei drew inspiration from the contemporary Western theories of equal rights for men and women and rejected gender-specific aesthetic education. In 1913, Cai Yuanpei delivered a speech at Chengdong Girls' School in Shanghai, praising the institution for providing art courses for female students and suggesting that "As long as women could study, their achievements would be the same as those of men." Cai Yuanpei's second daughter, Cai Weilian, also became a renowned art educator with her father's influence.

Why is aesthetic education important for women? The founder of Chengdong Girls' School, Yang Baimin, stated in Shun Pao in 1907 that "art is notably the cornerstone of women's independence." Lu Fengzi, an art educator, had appealed to the public to combine women's art education and vocational education. He founded the Zhengze Vocational School in DanYang in 1912 and was a pioneer in the creation of art practice classes to help poor female students complete their education and find employment.

The aesthetic preferences of women artists in the early Republic of China progressively emerged under the strong effect of modern aesthetic education and ideological trend. Traditional Chinese painters and Western painters studied in very different ways. The former relied on homeschooling and stressed inherited mentorship, while the latter tended to study overseas. In terms of artistic style, female Chinese painters mostly adhere to traditional painting skills in comparison to female Western painters, who prefer to integrate Chinese and Western drawing techniques and have a more personal style.

It should be emphasized that female painters demonstrate the distinct appeal of women art based on their gender status. Professor JinQijing of Shanghai art school authored an article titled "Women and Arts" in which she noted that "women are the favorites of Venus". Women have remarkable qualities in art, reflected in their intuition, a love of flowing art curves, and the sensation of true and pure affection.

Under the trend of women's aesthetic education in the early Republic of China, the female painters injected "her power" into art of painting and women's aesthetic education with abundant creativity. The emancipation of female consciousness has prompted female painters to bravely express themselves through painting, exploring the meaning of life and rewriting it, thus renovating women history.

The International Female Contemporary Art Exhibition, Existence · Her Power, will showcase the works of two deceased female painters, Fang Zhaoling and Yuen Chee ling, who had shown the distinctive charm of women's art in the context of their own gender, through which we will also get a glimpse of the glamorous female painters of the last era.

藝術尤為女子自立之基礎

文／馬思邈、翁柏詩、蔡浩華、吳浩雙、韋琪睿、柯佳昕

20 世紀初國內美育思潮興起，蔡元培借鑒西方近代男女平權理論，反對以性別區分美育。1913 年蔡元培在上海城東女學發表演講，肯定學校為女學生開設美術課程，並鼓勵「女子若有所學，他日之成就，定可與男子同」。蔡元培的二女兒蔡威廉也在父親的影響下，成為著名的美術教育家。

「為什麼女性需要美育？」城東女學的創辦者楊白民，在 1907 年《申報》發文稱「藝術尤為女子自立之基礎」。美術教育家呂鳳子主張女子藝術教育與女子職業教育相結合，他在 1912 年創辦丹陽正則女子職業學校，率先創設藝術實踐課程，幫助貧困女學生完成學業、解決就業。

正是在近代美育思潮及實踐的深刻影響下，民國女畫家的風貌逐漸明晰。國畫家和西畫家兩者求學取向迥異：國畫家多依憑家學、注重師承；而西畫家傾向海外求教。在藝術視野上，女國畫家多遵循傳統國畫技術，而女西畫家喜愛中西兼采，更具個人風格。

值得注意的是，女畫家們從自身性別處境出發，展現出女性藝術的獨特魅力。時任上海美專教授的金啟靜撰文〈女性與美術〉一語見地指出：「女性，是美神的寵兒」，女性的特殊天賦體現在直覺感應、性喜曲線流動、真摯純愛的心境等。

民國女子美育思潮下的女畫家群體以豐沛的創造力為繪畫藝術、女子美育注入「她力量」。女性意識的解放促使女畫家們通過繪畫勇敢表達自我，並藉此探尋生命意義，改寫人生，翻新女性歷史。

「存在 · 她力量」—— 國際女性當代藝術展將在本次展覽中展出兩位已逝女性畫家方召麐與源子玲作品，她們從自身性別處境出發，展現出女性藝術的獨特魅力，而我們也藉以一睹上個時代女性畫家的風華。

FANG ZHAOLING

方召麐

Fang Zhaoling is a master in the transformation of Chinese painting and ink. Born in Wuxi in 1914. Fang studied calligraphy and painting with Qian Songyan, and Chen Jiucun since 1933. In the same year, she participated in the "White Wave Art Society" exhibition in Wuxi. She attended the University of Manchester, majoring in Modern European history in 1937. In 1951, she held an art exhibition alongside her teacher Chao Shao-an in Japan and published her recent works album in Tokyo. She later become the student of Chang Dai-Chien, one of the greatest artists in the 20th–century, and attended the University of Hong Kong in 1954 where she studied Chinese philosophy and literature under Jao Tsung-I and Liu Bai-Min, masters of Chinese studies. Her solo exhibition was held at the University of Hong Kong in 1955 and continued her PhD study at Oxford University in 1956. In 1970, she spent a year in Chang Dai-Chien's place in Carmel, USA topaint landscapes.

Fang has held solo exhibitions in major universities and global museums. In 1957 and 1958, she was invited to in University of Munich, Oxford University, and Cambridge University for solo exhibitions.

In 1960, she held solo exhibitions at the Museum of the University of Oregon, the De Young Memorial Museum, and the Chinese General Chamber of Commerce. In the 1980s, her solo exhibitions were held at National Art Museum of China, Jiangsu Provincial Museum, Huishan Museum in Wuxi, Shanghai Municipal Museum, etc. In September 1988, her works were again showcased at the University Museum and Art Gallery in Hong Kong. Throughout the years, Fang's works have been selected and awarded in various large-scale international painting competitions as well as collected by museums and galleries.

Fang's has published numerous publications, such as *A Collection of Flower and Bird Paintings* (Tokyo edition), *Fang Zhaoling's Collection* (London edition)*, A Collection of Calligraphy and Painting* (Shanghai edition)*, The Art of Calligraphy* (Hong Kong edition), etc.

一代國畫改造及水墨實驗的大師。出生於 1914 年，1933 年隨錢松嵒、陳舊村學習山水畫，1937 年到英國曼徹斯特大學攻讀歐洲近代史。1951 年與國畫大師趙少昂到日本舉辦畫展。1953 年師從張大千研習書畫，1954 年入讀香港大學，隨國學大師饒宗頤、劉百閔等研讀中國哲學及文學，1955 年在港大舉辦辦個人畫展，1956 年到英國牛津大學修讀文學博士學位。1970 年在張大千美國「可以居」隨侍聆教一年，創繪山水作品。

方召麐曾於世界各大院校及博物館舉辦個展：1957 年與 1958 年先後應邀在慕尼黑大學、牛津大學、劍橋大學舉辦個人書畫展，1960 年先後在美國奧利岡大學博物館、三藩市楊氏博物館及中華總商會舉辦個人書畫展，1981 年至 1986 年先後應邀在中國美術館、江蘇省美術館、惠山博物館、上海美術館等地舉辦個人書畫展，1988 年 9 月再次在香港馮平山博物館舉行大型個人書畫展。歷年來作品多次入選國內外大型書畫展覽並獲獎，為博物館、美術館收藏。出版《方召麐花鳥畫集》（東京版）、《方召麐作品集》（倫敦版）、《方召麐書畫集》（上海版）、《召麐畫藝》（香港版）等。

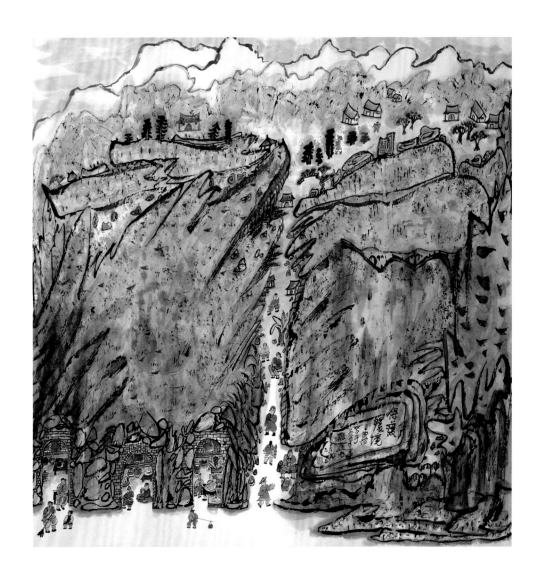

Environmental Protection
保護環境

Ink and color on paper
水墨設色紙本
126 x 96 cm
1990

源子玲
YUEN CHEE LING

Born in Penang in 1950. Graduated BFA (1985) and MFA (1986) degrees at the University of the Philippines. Awarded doctoral degree by Universiti Sains Malaysia in 2008.

Co-founder / Director of the Conservatory of Fine Arts since 1987. Initiator and the organizer of "Her Presence in Colours Exhibition - Asian International Women Artists Exhibition" series since 1993. Founder and president of the World International Women Artists Council –INWAC since 1999.

Held 15 solo exhibitions locally and abroad and numerous group exhibitions in important national and state museums in Malaysia, Argentina, Thailand, Taiwan, Japan, China, Australia, the United Kingdom, the USA, Denmark, Korea, Vietnam, and Moscow.

Her paintings are collected by many important organizations, such as the Malaysian National Art Gallery, USM Museum, Abu Dhabi Cultural Foundation Center, Bangkok Metropolitan Bank, Esso, Philip Morris and Pacific Bank, Olympic Fine Arts Museum in Beijing, Heshan Museum in Guangzhuo, China, and private collections.

1950 年出生於檳城，1985 年畢業於菲律賓大學 BFA 和 MFA（1986 年）學位，2007 年獲馬來西亞理科大學美術博士學位。

自 1987 年起擔任美術學院的聯合創始人／主任，1993 年起擔任「她的色彩空間──亞洲國際女性藝術家展覽」系列的發起人兼組織者，1999 年起擔任世界國際女性藝術家委員會 INWAC 的創始人兼主席。

曾在國內外舉辦 15 場個展，並在馬來西亞、阿根廷、泰國、日本、中國、澳大利亞、英國、美國、丹麥、韓國、越南和俄羅斯等國家和國家博物館舉辦多次群展。

作品被馬來西亞國家美術館、USM 博物館、阿布扎比文化基金會中心、曼谷大都會銀行、埃索、菲利普莫里斯和太平洋銀行、奧林匹克美術館（北京）和鶴山博物館（中國廣州）等各國藝術機構與私人收藏。

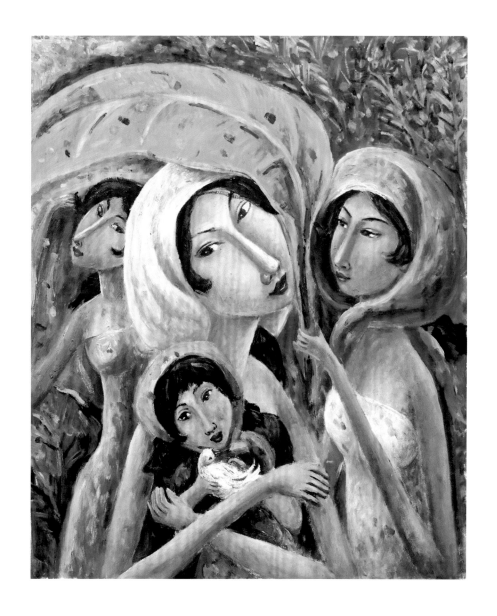

避雨 2
Shelter II

Oil on canvas
布面油畫
59 x 49 cm
2000

REDEFINING REALITY: THE FIRMAMENT BETWEEN FOLDS

虛實之間：
她們的皺褶與蒼穹

SABINE SCHNEIDER	薩賓娜・施耐德
CRISTINA BARROSO	克里斯蒂娜・巴羅佐
NATALIE MIEL	娜塔莉・蜜艾
ZHOU PING	周　平
LAM SHIU CHI	林小枝
GULISTAN	古麗斯坦
CHRISTINA CHEN	何沛珊
LIU CHENG MUI	廖井梅
CHARLOTTE ESCHENLOHR	夏洛特・愛神洛兒
LAURA BARBARINI	勞拉・巴巴里尼
JOAN MARIE KELLY	瓊・瑪麗・凱利
WANG DAOZHEN	王道珍
GUO ZICHEN	郭子晨
JANICE CHIU	趙健明
SANDRA ANGLISS	桑德拉・安格利斯
MEDIHA TING	定光琴
GAMMY KWOK	郭致因
AMY WU	胡美儀
LISA WOELFEL	麗莎・沃爾菲爾
HARUNA SATODONNA	佐藤令奈
MONCHING	孟　青
WONG CHUN YAN	黃俊欣
AYAKA NAKAMURA	中村綾花
CHAN SU WAN	陳詩韻
CECILE HIRSCHLER ALBERTI	塞西爾・赫斯勒・阿爾伯特

As the epidemic subsides, the world is witnessing a new recovery and vitality.

Existence · Her Power — International Female Contemporary Art Exhibition, organized by Art Life Foundation, is a magnificent Hong Kong art exhibition in March 2023, showcasing the works of local and international excellent female artists.

In today's art scene, female art has become the focal point, due to the feminismtrend since the 1960s and 1970s. Whether it is the women awakening moment as a whole, or the individual self-reflection, liberation, and transcendence, feminism art practices have explored and created art from different angles and dimensions, using "female ways" and "female languages" to express their thoughts and inquiries on issues such as ecology, society, ethics, identity, life, motherhood, and the body, thus transforming the existing art system to emphasize "Her" voice in the contemporary art world.

In the context of economic globalization and the development of information technology, with the changes in natural ecology and social ideology, different artists consider their diverse social and cultural backgrounds, to broaden their horizons, express themselves, and share creative ideas. With their unique insights, female artists provide afield for exploration and reflection on issues of creation, display, and institutional through presentation and exchanges.

The International Female Contemporary Art Exhibition makes efforts to promote contemporary art, emphasize women artists, and present a beautiful scene in a multicultural art scene with the original intention of "truth, beauty, and love".

LET HER TO BE HEARD. TRANSFORMING OF MARGINALIZED FEMALE ART TO CRUCIAL COMPOSITIONIN CONTEMPORARY ART

Associate Professor in the Department of Fine Arts at CUHK
Zhou Jin

將邊緣化的「她者」聲音，
轉為當代藝術世界的
重要部分

香港中文大學藝術系副教授
周晉

疫情消退，整個世界正在迎來新的復蘇和生機。天趣藝術人生基金會將舉辦的「存在·她力量」——國際女性當代藝術展，集中展示本地及海內外女性藝術家的作品，是三月香港的一大藝術盛事。

在當今藝壇，女性藝術已然成為備受關注的焦點，原因自然與20世紀六七十年代以來的女性主義思潮相關。不論是全社會女性自覺意識的蘇醒，或是個體的自我反思、解放和超越，女性主義藝術實踐從不同角度、層面的探索和創造，以「女性方式」「女性語言」，表達創作者對生態、社會、倫理、身份、生命、母性、身體等議題的思考和探究，推動並改變現有藝術體制，將邊緣化的「她者」聲音，轉為當代藝術世界的重要部分。

在經濟全球化環境下，伴隨著資訊化的發展，自然生態和社會意識形態的變化過程中，不同的藝術創作者思考各自多元社會文化背景和處境，打開廣闊視野，表達自我，分享獨特觀點和創見。女性藝術家們的創作，正是以其獨特的視角和洞察力，在呈現和交流間，提供了審視她們相關的藝術創造、展示及體制等問題的探討和思考現場。

此次國際女性當代藝術展覽，即是本著傳遞「真善美」與「愛」的初心，努力推動當代藝術發展，提升女性藝術和藝術家的能見度，為人們奉上多元文化圖景中一道美麗的風景線。

薩賓娜 · 施耐德

SABINE SCHNEIDER

Sabine Schneider, born in Berlin in 1956. She is the president of the Berlin Artists' Association, a member of the Berlin Professional Association of Visual Artists, the Max Liebermann Association, and DCKU.

Schneider graduated from the Berlin Academy of Fine Arts under Professor Wolfgang Petrick and received a degree in Fine Arts and Crafts in 1983. Since 1992 Sabrina has been teaching at the Hochschule für Film und Fernsehen in Potsdam-Barbergsburg and other institutions, as well as running herstudio. Since 2007, she has been the president ofthe Berlin Artists' Association, who is the first female president since the establishment of the association.

Her works have been exhibited in Germany, China, France, Scandinavia and Southern Europe. She has participated in numerous solo and group exhibitions and as the president of the Berlin Artists' Association, she has been involved in the development of international art projects and exhibitions also.

1956 年出生於德國柏林，柏林藝術家協會主席、柏林視覺藝術家專業協會會員、馬克斯 · 利伯曼協會會員、德中藝術文化交流協會會員。

畢業於柏林藝術學院，師從沃爾夫岡 · 彼得里克（Wolfgang Petrick）教授，並於 1983 年獲得美術和手工藝學位。自 1992 年以來，薩賓娜一直任教於波茨坦 - 巴貝爾斯堡的電影電視大學（Hochschule für Film und Fernsehen）和其他機構，同時經營自己的工作室。自 2007 年起擔任德國柏林藝術家協會主席至今，柏林藝術家協會誕生於 1841 年，她也是該協會的首位女性主席。

薩賓娜的作品在德國、中國、法國、北歐、南歐等國家展出，曾舉辦多次個展及參與群展，同時作為柏林藝術家協會的主席，她參與開發了多個國際藝術家專案和展覽。

Fictional Landscape No.2
虛構風景之二

Oil on canvas
布面油畫
120 x 100 cm
2018

克里斯蒂娜・巴羅佐

CRISTINA BARROSO

Cristina Barroso was born in 1958 in Sao Paolo, Brazil. She studied philosophy and fine art at Southern Illinois University and the San Francisco Art Institute. She was a guest professor at the Freie Kunstakademie Mannheim. Currently she lives in Stuttgart, Germany.

Barroso held countless solo and group exhibitions worldwide. She was the guest artist at the Jerusalem Center for the Visual Arts, the Actions Forum Praterinsel in Munich, the Schloss Plüschow in Mecklenburg-Vorpommern and at Marma art projects in Berlin. She also won numerous prizes and scholarships.

1958 年出生於巴西聖保羅，現居住於德國。曾於南伊利諾伊大學和三藩市藝術學院學習哲學和美術，並曾任曼海姆自由藝術學院客席教授。

巴羅佐在世界範圍內舉辦了多次個展和群展。曾在耶路撒冷藝術中心、慕尼克普拉特林塞爾行動論壇、梅克倫堡－前波美拉尼亞普呂紹城堡，以及曾為柏林馬爾馬專案駐場藝術家；並獲得了許多獎項和獎學金。

Alphabet
字母

Acrylic on Japanese paper on canvas
和紙丙烯、布面拼貼
180 x 70 cm
2022

娜塔莉 · 蜜艾

NATALIE MIEL

Born in La Mure, France in 1962. Attended National School of Art (École Nationale Supérieure des Beaux-Arts) in Paris and was the student of Jean Bertholle. Miel was the former general secretary of the French Association of Plastic Arts (AFAP) and Women's International Cultural Federation (FICF). She was the professor at the School of Plastic Arts of Saint-Denis (l'Ecoled'Arts Plastiques de Saint-Denis) from 1990 to 1993, and Blancs-Manteaux Workshop in Paris Centre City Hall.

Invited to participate in the creation of sculpture and decoration for varies movies such as *The Sun Assassinated* and *Deadline*. She attended over 50 group exhibitions and actively involved in Sino-French arts exchange activities. Miel has been invited to Beijing International Art Biennale, Paris Autumn Salon, and the Louvre Carrousel Salon. She is now permanently represented by galleries from the US, Switzerland, Lebanon, and several cities from France.

1962 年出生於法國拉米爾，巴黎國立高等美術學院畢業，曾任法國造型藝術家協會（AFAP）秘書長、國際婦女文化聯合會（FICF）秘書長、法國聖丹尼斯造型藝術學院教授及巴黎市政廳布蘭克斯 - 曼特奧劇院繪畫教授。

曾參與《被謀殺的太陽》及《死線》等多部電影的場景裝飾、雕塑設計。於世界各地舉辦多次個展及超過 50 場聯展，更活躍於中法藝術交流活動及展覽。曾受邀參加中國北京國際美術雙年展、秋季展、羅浮宮卡魯塞爾沙龍。在美國、瑞士、黎巴嫩及法國多個城市均有長期合作畫廊。

Peaceful Pigeon
和平鴿子

Oil on canvas
布面油畫
130 x 195 cm
2019

周 平

ZHOU PING

Zhou Ping, born in Sichuan province, China. Graduated from Fine Art Academy, Southwest Normal University with a master's degree in oil painting in 1998. In the same year, she was invited by William Lindhout, a Dutch postmodernism artist, to study at Rietveld Art Academy in Amsterdam, Netherlands. She is the specially recommended member of the Asian Art Association of Japan and a member of the Modern Art Association, International Art Critics Selection Committee A.M.S.C recognized artists. Currently she lives and works in Yokohama, Japan.

In 2004 she won the grand prize at the "Exhibition of Message from Young Artists" at Gallery Sudoh in Ginza, Tokyo, Japan. In 2006, she was selected as one of the "The Highly Anticipated Contemporary Artists" in the art magazine *The Window of Art*. In 2008, she won the Muse Award for the Competition Exhibition of Think Global Art Japan. In 2017, she won the Kusakabe Award at the Japan Modern Art Association Exhibition.

生於中國四川，1998 年畢業於西南師範大學美術學院油畫碩士、在學中應荷蘭後現代主義藝術家 William Lindhout 之邀，赴荷蘭阿姆斯特丹若維爾德藝術學院（Rietveld Art Academy）訪學。先後被特例推薦為日本亞細亞美術協會會員、日本近代美術協會會員，國際美術評論家選考委員會 A.M.S.C 認定藝術家。現工作生活於日本橫濱。

2004 年榮獲東京銀座 SUDOH 美術館舉辦的「青年藝術家傳言展」最優秀獎，企劃個展獎。2006 年被日本《美術之窗》雜誌評為當代倍受矚目藝術家之一。2008 年榮獲日本世界堂 Think Global Art Japan 繪畫龔古爾展繆斯獎。2017 年榮獲日本近代美術公募展庫薩卡貝獎。

作品為日本、德國、西班牙、比利時等國美術館、私人收藏。

"Food · Spring " of "Food · Four Seasons" series
食 · 四季系列之食 · 春

Oil on canvas
布面油畫
60 x 146 cm
2020

林小枝

LAM SHIU CHI

Lam Shiu Chi is currently the advisor of the Hong Kong Art Researching Association, the advisor of the Cai Yi Modern Painting Research Association, the honorary president and advisor of the HK Art of Nature International Female Art Research Society, and the advisor of the Galaxy Art Association of Hong Kong.

Lam was born in Hong Kong in 1940, whose father was the famous literary and artistic theorist Lam Woon-ping. Her works have been widely known around the world and in dozens of cities in China, and she has won many awards and her works have been selected for the "World Expo of Chinese Artists' Achievement", "100 Elite Artists" and "Hong Kong Museum of Art Archive". She has also published thousands of paintings and illustrations in art magazines and newspapers at home and abroad.

In 1992, she was awarded "Outstanding Achievement on Art Creation for Female in the World Certificate" by the American Biographical Institute. In 2010, she publication, *Modern Art Collection of Lam Shiu Chi*, was collected by the Metropolitan Museum of Art, New York, and Hong Kong Central Library.

香港美研會顧問、彩頤現代畫研究會顧問，天趣國際女性藝術研究會榮譽會長兼顧問，香港星河畫藝會顧問，專業畫家。

1940 年出生於香港，父親是著名文藝理論家林煥平。作品遠播世界多地及中國數十個城市，更多次獲獎，作品入選《世界華人藝術家成就博覽大典》、《精英藝術家百人集》、《香港藝術館檔案》。在海內外各地美術雜誌及報刊發表畫作及插圖達數千幅。

1992 年獲美國世界名人傳記協會頒發「世界婦女藝術創作卓越成就傑出女士」証書。2010 年出版《林小枝現代畫精選集》由美國紐約大都會博物館、香港中央圖書館等收藏。

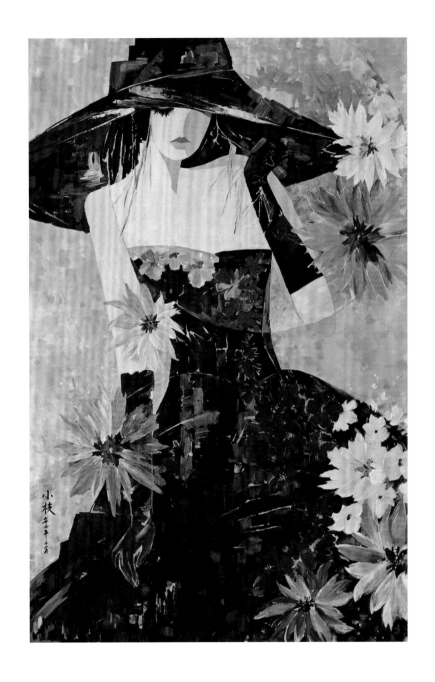

A Fashionable Girl A
新潮女郎 A

Acrylic on canvas
布面丙烯
88 x 55 cm
2020

古麗斯坦
GULISTAN

Gulistan graduated from the Academy of Fine Arts from the Minzu University of China in 1994 with a bachelor's degree. In 2003, she graduated from the College of Fine Arts of the Capital Normal University majoring in oil painting. She then obtained the Master's of Education from Flinders University, Australia in 2007. Gulistan now teaches at Capital Normal University, Beijing.

Gulistan's works have been exhibited at the National Art Museum of China, Shanghai Art Museum, Today Art Museum, National Taiwan Normal University, Sejong Center, Malmö, Hong Kong Exhibition Center, Deutsches Röntgen-Museum, Embassy of the People's Republic of China in Ireland, Dubai International Convention and Exhibition Centre, Hungarian Cultural Center, CAFA Art Museum, and other institutions.

Her works have been collected by the National Art Museum of China, European Union Ambassadors, Dubai Royal Family and many other collectors. In 2020, the organizing committee of the International Federation of Female Artists in Rome, Italy, presented Gulistan with the "Contemporary Art Creation Award".

1994 年畢業於中央民族大學美術系本科學位，2003 年畢業於首都師範大學美術學院油畫專業，2007 年獲得澳大利亞 FLINDERS 大學教育碩士，現任教於首都師範大學。

Gulistan 古麗斯坦的作品曾多次在中國美術館、上海美術館、今日美術館、台灣國立師範大學、韓國首爾世宗會館、瑞典馬爾默、香港展覽中心、德國杜塞爾多夫雷姆沙伊德博物館、愛爾蘭大使館、迪拜科技會展中心、匈牙利文化中心、中央美術學院美術館等機構展出。

作品獲中國美術館，歐盟大使，迪拜皇室及多國收藏家收藏。2020 年，義大利羅馬的國際女藝術家聯合會組委會為古麗斯坦頒發了「當代藝術創作獎」。

Memory of Portrait - The Age of Innocence II
記憶中的肖像 - 純真年代 II

Mixed media on canvas
布面綜合材料
80 x 60 cm
2020

何沛珊

DONNA
HO

Ho Pui San, Donna, is an artist and art columnist in Macau. She has obtained doctorate and master degree of fine art in University of Paris 1 - Pantheon-Sorbonne in France, and master degree in oil painting in Guangzhou Academy of Fine Arts. She is a member of Macau Artist Society, honorary consultant of International Women Artists Association – Macau and member of Les artistes de la Glacière in Paris. She lives in Paris currently.

Ho has participated in various exhibitions and obtained awards in Macau and nationally. Her painting, video and installation works are shown publicly in Paris and in other cities in France and all over the world.

自由職業藝術家、藝術評論專欄作家。法國巴黎第一大學（先賢祠 - 索邦大學）造型藝術博士及碩士，廣州美術學院油畫系碩士。澳門美術協會會員，國際女藝術家協會澳門分會名譽顧問， 巴黎加斯爾藝術家協會會員。現工作生活於法國巴黎。

油畫作品多次參加澳門及全國展覽並獲獎，繪畫、影像及裝置作品亦多次在法國巴黎及世界多國城市公開展出。

Red Composition
紅色構成

Oil on canvas
布面油畫
120 x 120 cm
2018

廖井梅

LIU CHENG MUI

Born in Beijing, Liu Cheng Mui graduated from the high school affiliated to CAFA in 1988 and enrolled in the Central Academy of Fine Arts in the same year. She received the scholarship from the Ministry of Culture to stay in the Soviet Union after a year of study. In1996, she graduated from Moscow State Academic Art Institute named after V.N. Surikov with a Master of Fine Arts degree. Liu has taught at the Central Academy of Fine Arts in Beijing and at HKU School of Professional and Continuing Education from 2003 to 2020. She is currently a member of the Chinese Artists Association and vice chairman of the Hong Kong Artists Association.

Liu's works have been widely collected by the Hong Kong Museum of Art, Hong Kong Heritage Museum, Jiangsu Provincial Art Museum, Zhejiang Provincial Art Museum, Guan Shanyue Art Museum, Harbin Art Palace Print Museum, Heilongjiang Art Museum, Shenzhen Art Museum, China Woodcut Museum, and other cultural institutions and museums.

生於北京，1988 年畢業於中央美術學院附中，同年考入中央美術學院，修讀一年後獲文化部獎學金留學前蘇聯。1996 年畢業於俄羅斯國國立蘇里柯夫美術學院，獲藝術碩士學位。曾任教於北京中央美術學院，2003-2020 任教香港大學專業進修學院。現為中國美術家協會會員，香港美協副主席。

作品獲收藏於香港藝術館、香港文化博物館、江蘇省美術館、浙江省美術館、關山月美術館、哈爾濱藝術宮版畫博物館、黑龍江省美術館、深圳畫院、中國版畫博物館等文博機構。

Shimmer
映日

Oil on canvas
布面油畫
100 x 150 cm
2020

夏洛特・愛神洛兒

CHARLOTTE ESCHENLOHR

Charlotte Eschenlohr was born in Munich. She studied business management and received her doctorate degree in commerce. She worked in investment, management consulting and accountancy. Eschenlohr lives and works in Munich, Beijing and New York. She transformed into a professional artist in 2002, and studied art with German artist Markus Lüpertz and the New York artist Donald Baechler.

Charlotte has a permanent studio in Munich, Germany. She also maintained a studio in New York from 2004 until 2012. Since 2014 she also set up a studio in Beijing. She has studios in the Europe, America, and Asia. It allows her to become very active in the art scene globally and in important collections.

出生於慕尼克，擁有經濟學管理專業博士學位。她曾從事投資管理，管理諮詢和會計師行業。於 2002 年轉型成為職業藝術家，並師從於德國藝術家馬庫斯・呂佩爾茲和紐約藝術家 Donald Baechler。

夏洛特在慕尼克常設工作室；2004 年至 2012 年在紐約設有工作室；自 2014 年起在北京設立獨立工作室至今。由於她的工作室遍佈於歐洲，美洲和亞洲，使得她的職業生涯獲得極為活躍的全球性展覽和重要的收藏。

Butterfly
蝴蝶

Mixed media on canvas
布面综合材料
200 x 200 cm
2019

勞拉·巴巴里尼

LAURA BARBARINI

Laura Barbarini was born in 1956, Sao Paulo, Brazil. Moved to Rome with family in 1958. She graduated from the Accademia di Belle Arti di Roma. And she learnt from the Italian master Enzo Brunnoli.

Barbarini has attracted much attention for her participation in two art exhibitions called "Women and Art" in 1979 and 1980. She has numerous solo and group exhibitions in Italy and over the globe. Her works are collected in various museums, private institutions and collections.

1956 年生於巴西聖保羅。1958 年隨家人移居羅馬,並先後在羅馬藝術高中和羅馬藝術學院完成學業,師從藝術大師恩佐·布魯諾利。

她因先後參加了 1979 年和 1980 年兩場名為「女性與藝術」的藝術博覽會而開始受到矚目。而後在意大利及全球各個國家舉辦多次個展和群展,作品為全球各大博物館、機構及私人收藏。

Into the Blue
走向藍色

Oil on canvas
布面油畫
50 x 40 cm
2018

瓊・瑪麗・凱利

JOAN MARIE KELLY

Joan Marie Kelly is a visual artist. She has been senior lecturer at Nanyang Technological University, in Singapore since 2005. Kelly has had prominent solo exhibitions in New York, New Delhi, Singapore, Kolkata, Baltimore, and Fez Morocco.

Kelly crafts art engagement as a means of mediation with marginalized communities. In Kelly's handling, Art becomes a point of encounter and a process to generate empathy and creativity, integrating complex interwoven community relations. She has been organizing participatory art workshops with sex workers in Kolkata and India since 2009, and the founder of "The Kolkata Women's Dialogue" in Kolkata.

　　視覺藝術家，新加坡南洋理工大學高級講師。曾在紐約、新德里、新加坡、加爾各答、巴爾的摩和摩洛哥費茲舉辦個展。並獲第 16 屆世界和平展一等獎——傑出社會藝術獎（2012），全北雙年展肖像畫成就一等獎（2012），西康涅狄格州立大學藝術大師榮譽獎（2006）。

　　她將藝術參與作為與邊緣化社區進行調解的一種手段。自 2009 年起與印度加爾各答的性工作者一起舉辦參與式藝術研討會，並擔任「加爾各答婦女對話」的創始人。她的諸多藝術創作即圍繞此展開。

Community Bonds
社區紐帶

Giclee print
藝術微噴
30 x 30 cm / 2022

Morning Ritual
晨間儀式

Giclee print
藝術微噴
30 x 30 cm / 2022

Bonds of Color
彩色紐帶

Giclee print
藝術微噴
30 x 30 cm / 2022

The Red Cloth
紅布

Giclee print
藝術微噴
30 x 30 cm / 2022

王道珍

WANG DAOZHEN

Wang Daozhen graduated from the Beijing Institute of Fashion Technology in 1999 with a bachelor's degree in Arts and Crafts Design. From 2003-2004, she studied the folk art assistant postgraduate course and integrated painting language at the Central Academy of Fine Arts from 2010-2011, as well as the mural arts senior seminar from 2011-2014.

Wang is currently the vice chairman and secretary general of the Hong Kong Artists Society, secretary general of the Association of International Distinguished Women Artists, and a member of the Hong Kong Artist Association and the China Mural Association.

Wang has held numerous solo exhibitions and participated in joint exhibitions both at home and abroad, including "Wang Daozhen Oil Painting Exhibition" in 2017, "The Germany-China Art and Peace Exchange Exhibition" in 2017, "The 3rd National Mural Painting Exhibition" in 2014, at the Art Museum of Central Academy of Fine Arts, "Magnificent Motherland, Prosperous Hong Kong - Group Exhibition of Famous Artists" in 2016, CPPCC, Beijing.

1999 年畢業於北京服裝學院工藝美術設計本科,獲學士學位。2003-2004 年就讀於中央美術學院民間美術助教研究生課程班,2010-2011 年就讀於中央美術學院綜合繪畫語言研修班,2011-2014 年就讀於中央美術學院壁畫高研班。

現為香港畫家協會副主席兼秘書長,薈萃國際女畫家協會秘書長,香港美協會員,中國壁畫學會會員。

曾多次舉辦個展及參與國內外聯展,包括「漸行見畫──王道珍油畫作品展」(2017),「德中藝術與和平交流展」(2017),「第三屆全國壁畫大展」(中央美術學院美術館,2014),「美麗祖國 幸福香港──名家聯展」(北京政協,2016)。

Cheeta
小豹子

Watercolor, gouache and mixed media
水彩和水粉綜合材料
45 x 30 cm
2022

郭子晨

GUO ZICHEN

Guo Zichen is an artist, member of the International Women's Art Exchange Association. She studied with the famous Italian artist Paolo Laudisa in 2016 and 2018.

Guo was awarded the "Contemporary Art Creation Award" by the organizing committee of the International Women's Art Exchange Association. She has participated in many exhibitions at home and abroad, including the "Youth Art Biennale" in 2021 and the "2nd China - Italy Young Artists Joint Exhibition" in 2017.

自由藝術家，國際女藝術家聯合會會員，2016 年與 2018 年於義大利著名藝術家 PaoloLaudisa 工作室學習。

曾獲得國際女藝術家聯合會組委會頒發的「當代藝術創作獎」。並多次參展國內外展覽，包括青年藝術雙年展（2021），與第二屆中意青年藝術家聯展（2017）。

Oriental
來自東方

Mixed media
綜合材料
80 x 60 cm
2022

趙健明

JANICE CHIU

Janice Chiu is a member of the Hong Kong Artists Association, also the vice president of the International Women Artists Council - Hong Kong. She is the author of the column "Architecture, Art, and Design" in ET Net and also the columnist of "Travel around the World" in Hong Kong Economic Journal.

Her works have been widely exhibitedin domestic and international exhibitions, and published in art journals. Her works are widely favorably acclaimed.

香港美協會員，世界女藝術家聯會（香港）副主席，香港油畫研究會會員。執筆網媒《經濟通》專欄「建築・藝術・遠方」；《信報》「環宇遊蹤」等專欄撰稿人。

作品展出於諸多海內外展覽，並在多家藝術期刊發表，廣獲好評。

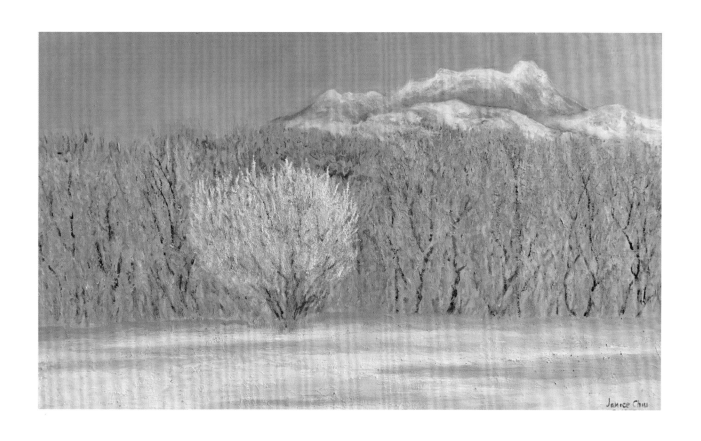

Snow Forest
雪林

Oil on canvas
布面油畫
60 x 100 cm
2022

桑德拉 · 安格利斯

SANDRA ANGLISS

Sandra Angliss is an artist and art teacher, living and working in Victoria, Australia. She graduated from RMIT, Melbourne with a bachelor's degree in painting and printmaking in 1988. In 1991, Angliss obtained a bachelor of education in visual arts educationfrom Melbourne University, Melbourne. In 2001, she gained a bachelor of education from Deakin University, Melbourne.

Sandra has been the honorary secretary in International Women Artists Federation (IWAF) since 2018. She was the honorary secretary of the International Women Artists Council from 1999-2017. In 1996, Sandra was an artist in residence at Conservatory Fine Arts, Penang, Malaysia.

藝術家及藝術老師。現居澳洲維多利亞州。1988 年畢業於皇家墨爾本理工大學，獲文學學士學位（繪畫與版畫）；1991 年畢業於墨爾本大學，獲教育學士學位（視覺藝術教育）；2001 年畢業於墨爾本迪肯大學，獲教學學士學位。

2018 年至今任國際女性藝術家聯盟（IWAF）名譽秘書長，曾於 1999-2017 年任年國際女性藝術家理事會榮譽秘書，1996 年時曾任馬來西亞檳城音樂學院駐地藝術家。

Cornacopia
聚寶盆

Oil, food dye and marker pen on canvas
布面油畫、食用染料、馬克筆
75 x 60 cm
2020

定光琴

MEDIHA
TING

Mediha Ting, was born in Belgium, grew up in Hong Kong.She received her education in the US and the UK. In 1995 while she was studying Fine Arts at California College of Arts, she received Honorable mention in the All - College Honors Awards. Ting graduated from the Byam Shaw school of Arts, University of the Arts London in 2000. She later earned a master degree in Art Policy and Management at Birkbeck College in London. She is currently, the founder of Ting Art Studio, committee of Young Artist Development Foundation, committee of International Association of Chinese Traders, and director of Mid-Level Rotary Club.

Ting had various solo exhibitions in London, America, Shanghai, Hong Kong, UK and Taiwan and participated in many group exhibitions and art fairs all over the world. Including "Art Stage Singapore", 33 Auction Singapore, "Contemporary Art Auction at Centre for Chinese Contemporary Art (CFCCA)" in Manchester, "Asian Art in London and Scope Basel Art Fair" in Switzerland.

出生於比利時，成長於香港，於美國及英國接受藝術教育，1995 年就讀美國加州藝術學院時，獲全美大學校際公開賽優異獎。2000 年於倫敦藝術大學獲得藝術學學士學位，2003 年獲得藝術政策與管理碩士學位。現為 Ting Art Studio 創辦人，藝育菁英委員，國際華商協進會理事，半山區扶輪社理事。

曾於英國、美國、上海、台灣及香港多次舉辦個人展覽，作品在世界各地多個藝術博覽會展出，包括「倫敦亞洲藝術週」、「瑞士 Scope Basel 藝術博覽會」、「新加坡 Art Stage 藝術博覽會」和入選新加坡 33Auction 拍買會等。

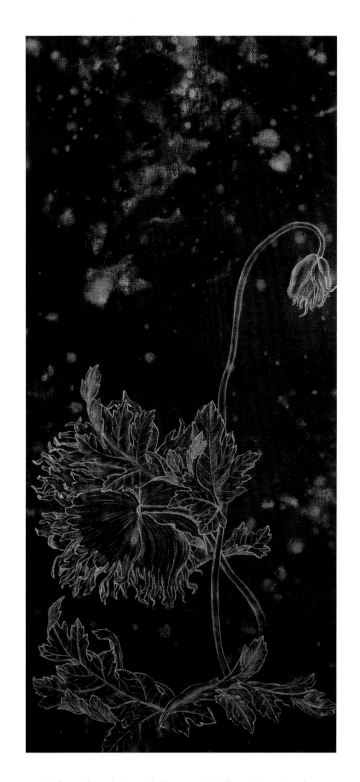

Dialogue through time with Giuseppe Gastiglione - Poppy Rememberance
與朗世寧超時空對畫系列 - 罌粟花 懷念

Acrylic on canvas 布面丙烯
60 x 26 cm
2022

郭致因

GAMMY KWOK

Gammy Kwok, with extensive experience in the health and beauty product design and brand creator, began her creative journey in the arts nine years ago. Currently a creator on the Ucollex NFT platform, Kwok started her new Chinese ink art training with master Choi Hoi Ying, an art lecturer from Hong Kong Polytechnic University, and John Wong. She enrolled in the Chinese University ink art diploma program.

She participated in the Affordable Art Fair 2020, exhibitions in Amaz Gallery and Shout Gallery.

UCOLLEX NFT 平台藝術家之一，從事品牌及產品設計超過 20 年，並在九年前開始了她的藝術創作之旅，跟隨香港理工大學藝術講師蔡海鷹及黃約翰學習新水墨，曾修讀中文大學專業進修學院第四屆新水墨文憑課程。

曾參與 2021 年度 Affordable Art Fair 及多個畫廊舉辦的展覽，包括 Amaz Gallery 和 Shout Gallery 等。

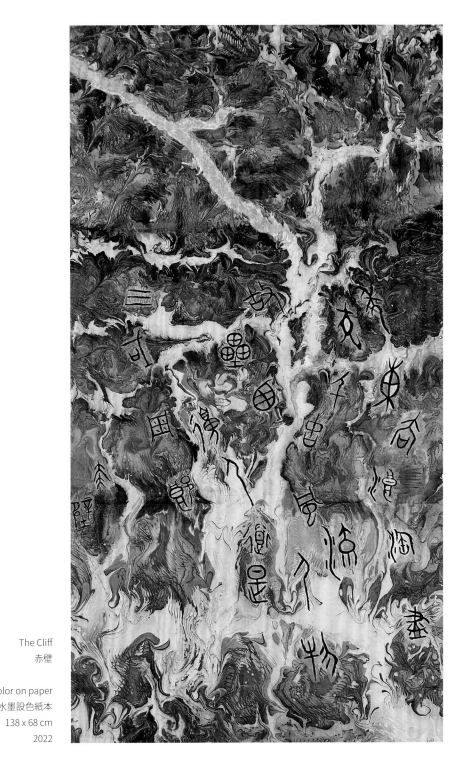

The Cliff
赤壁

Ink and color on paper
水墨設色紙本
138 x 68 cm
2022

胡美儀

AMY WU

Amy Wu is a famous entertainer and professional psychological counselor. In 1977, she won the final champion in a performing competition organized by Television Broadcasts Limited, and thus entered the entertainment industry. Amy excels in both singing and performing. She has acted in more than 200 theater productions and films and recorded more than 30 albums. She was awarded the Hong Kong Drama Award for Best Actress (1992) by the Hong Kong Federation of Drama Societies and "Hong Kong Outstanding Women Award" by the Hong Kong Women Development Association.

Wu then studied psychotherapy, focusing on soothing the soul with art. She graduated with a bachelor's degree in psychological counseling in 2018 and a master's degree in 2021. In 2021, Amy was awarded "Women's Initiative for aging successfully" by Wings Hong Kong in recognition of her extensive service to the community through charitable counseling during the pandemic.

　　資深演藝人及專業心理輔導工作者。1977 年獲香港無線電視廣播有限公司主辦之「聲寶片場」總決賽冠軍，從而進身演藝行業。唱演皆優，演藝作品超過 200 部，灌錄唱片 30 多輯。曾獲香港戲劇協會頒發之香港舞台劇獎「最佳女主角獎」（1992）、香港婦聯頒發「香港傑出女性大獎」。

　　而後開始轉向心理療愈領域，致力於用藝術撫慰心靈。2018 年修畢心理輔導學士學位，2021 年修畢心理輔導碩士學位。2021 年獲詠翔（香港）Wings Hong Kong 婦女團體頒發「傑出活齡女性——卓越大獎」，表揚在疫情期間，用慈善心理輔導廣為社會大眾服務。

Amy Wu - Stage of Spirit & Heart
胡美儀 · 心靈舞台

Mixed media on paper
綜合材料
24 x 32 cm
2022

麗莎・沃爾菲爾
LISA WOELFEL

Lisa Woelfel was born born in Schweinfurt in 1988 and moved to Leipzig in 2017. She studied painting at the Academy of Fine Arts in Nuremberg with Professor Thomas Hartmannfrom 2009 to 2017. She was nominated of Eb Dietzsch Art Prize for Painting in 2018, and awarded Advancement Award of the NürnbergerNachrichtenin 2015. She had artist residency at International Art Colony Skopje as a representative of the city of Nuremberg in 2017. She was awarded the Promotion of Culture by the City of Nurembergby the Mayoress of Culture Division of Nuremberg in 2021.

1988 年出生於巴伐利亞施韋因富特，2017 年移居至萊比錫。2009 至 2017 年於紐倫堡美術學院跟隨 Thomas Hartmann 教授學習繪畫。2018 年獲 Eb Dietzsch 繪畫獎提名，2015 年獲紐倫堡新聞藝術獎先進獎，及於 2017 年斯科普里 International Art Colony 中擔任紐倫堡代表。於 2021 年更獲文化部部長頒發紐倫堡城市文化推廣獎。

Drift
漂移

Ink and crayon on linen
亞麻 水墨 蠟筆
110 x 80 cm
2020

佐藤令奈

HARUNA SATO

Haruna Sato graduated from the Oil Painting Department of Tama Art University in 2008, and began to study for a master's degree in the Oil Painting and Printing Department of Aichi Prefectural University of Art in 2018. Her major exhibitions include "The Temperature of the Skin" Exhibition in Tokyo in 2008, "East Asia Collaboration Project - Sato Rena Exhibition" at the Philip Kang Gallery in Seoul in 2010, "Body Temperature Story" Exhibition at Shanghai Xunyishe Gallery in 2018 and "Border : The Balance of the World" at Takasaki Viento Arts Gallery in 2021.

Since winning the Tokyo Wonder Wall in 2009, Sato has been very active and has made remarkable progress. She has won the Nanjing International Art Festival Award, the Artist Sponsorship Award issued by the Kamiyama Foundation and other awards. She also participated in international art fairs in Taipei, New York, India, Seoul, Tokyo and other countries. She has been showing her new works in the art biennale in Nakanojo, Gunma Prefecture, Japan.

2008 年畢業於多摩美術大學油畫系，2018 年開始於愛知縣立美術大學油畫與印刷系攻讀碩士學位。主要展覽包括 2008 年「肌膚的溫度」展於東京、2010 年「東亞協作項目 ── 佐藤令奈展」展於首爾 Philip Kang 畫廊、2018 年「體溫物語」展於上海熏依社畫廊及 2021 年「Border：世界的平衡」展於高崎 Viento Arts Gallery。

自 2009 年東京 Wonder Wall 獲獎以來，佐藤一直非常活躍並取得了顯著的進步。她先後獲南京國際藝術節大獎，Kamiyama 基金會頒發的藝術家贊助獎等獎項；參加了台北、紐約、印度、首爾、東京等地的國際藝博會，並且持續在日本群馬縣中之條雙年展中呈現全新的作品。

Mellow 1
芳醇 1

Oil on canvas
布面油畫
65.2 x 53.2 cm
2018

孟青 MONCHING

Monching is a young female painter and writer from Taiwan, graduated from the Business School of National Cheng Kung University. She has participated in the "2nd Taiwan Colored Pencil Invitational Exhibition", and "Her Power - Global Contemporary Women's Art Online Exhibition". Her works often portray women from different countries and backgrounds, so as to explore their situations under specific social environments.

　　台灣年青女畫家及作家，畢業於台灣成功大學商學院。曾參展「鉛掛第2屆全台灣色鉛筆邀請展」，及「她力量──全球當代女性線上展」。作品常以不同國家和背景的女性為主題，藉由畫面探討社會環境下女性的處境。

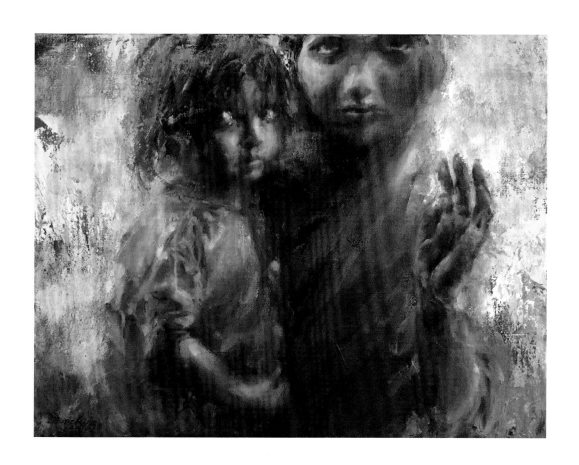

To Beg, to Accuse
乞求・控訴

Oil on canvas
布面油畫
31.5 x 41 cm
2015

黃俊欣

WONG CHUN YAN

Esther Wong graduated from the Education University of Hong Kong in 2018 and obtained Master of Arts from the Fine Arts Department, the Chinese University of Hong Kong. Wong loves illustrations and exploring various emotions in her artwork by using color pencil, acrylic, and digital painting as her main medium. Her artwork participated in the 2022 Art Central "Made in Hong Kong".

2018 年畢業於香港教育大學,並於 2022 年完成香港中文大學藝術文學碩士課程。黃俊欣喜愛探究及繪畫生活中的各種情感,創作媒介多為木顏色、水彩、電繪等。其作品曾參加 Art Central 2022 的「香港製造」展覽。

Part of Me
部分的我

Color pencils and water color on paper
針筆與茶紙本
21 x 21 cm x 4
2022

中村綾花
AYAKA NAKAMURA

Ayaka Nakamura, born in Tokyo in 1988. She studied abroad in Missouri, USA from 2005 to 2006. In 2013, she graduated from the Department of Oil Painting of Musashino Art University, majoring in printmaking. Nakamura has done art residency in the United States, Denmark, and China in recent years. She creates drawings and video art with the goal of making delicate but powerful images. The main exhibitions include "First" solo exhibition at Pepper's Gallery in Tokyo in 2013, "5 Different Landscapes" Exhibition at Berlin's Epicentro Art in 2015, "Shine" Solo Exhibition at Tokyo Esha Gallery in 2018, and "Ayaka Nakamura Solo Exhibition" at Bunkamura Box Gallery in Tokyo in 2021.

　　1988 年出生於東京，2005 至 2006 年期留學美國密蘇里州，2013 年於武藏野美術大學油畫系版畫專業畢業。中村綾花近年來在美國、丹麥、中國都進行過駐地創作。她以製作纖細而有力的畫面為目標，創作繪畫和影像藝術。主要展覽包括 2013 年「先」個展展於東京 Pepper's Gallery、2015 年「5 Different Landscapes」 展 於 柏 林 Epicentro Art、 2018 年「Shine」個展展於東京江夏畫廊及 2021 年「中村綾花個展」 展於東京 Bunkamura Box 畫廊。

Over the Wind
在風中

Acrylic and plating pigment on canvas
布面丙烯、電鍍顏料
45 x 60 cm
2022

陳詩韻

CHAN SU WAN

Chan Su Wan graduated with a Master of Expressive Arts Therapy and a Bachelor of Social Science (Psychology) from the University of Hong Kong. She is now studying Masters of Arts in Fine Arts at the Chinese University of Hong Kong. She started doing psychotherapy with multi-modal arts in 2017. She belives that art is powerful in discovering the self, facilitating dialogue with the world, and making changes. Since 2020, she started to explore how arts can be applied in the in life and reveal art in daily life.

表達藝術治療師。 香港中文大學美術碩士，香港大學表達藝術治療碩士，香港大學社會科學學士（心理學）。2017 年開始以多元藝術作心理治療。協助個案與外界以藝術對話，透過創作連結心靈，探索未知的內在情感。2020 年開始，探索藝術於生活的呈現。

In - Evitable Pain 1
無 - 可避免的痛 1

Acrylic on canvas
布面丙烯
150 x 100 cm
2022

塞西爾 · 赫斯勒 · 阿爾伯特

CECILE HIRSCHLER ALBERTI

Cecile Hirschler Alberti is an American - Peruvian artist based in New York City. She graduated from the Rhode Island School of Design with a BFA Printmaking in 2016; and received her MFA in Studio Art from NYU Steinhardt in 2022. Hirschler has already shown with influential spaces in New York since her graduation, including Palo Gallery, O'Flaherty's and 8-Ball Community. Her works are in private collections in Peru, New York and London.

美籍秘魯藝術家，現居住於紐約。赫斯勒於 2016 年畢業於羅德島設計學院，獲得版畫藝術學士學位；並於 2022 年獲得紐約大學斯坦哈特藝術學院的藝術碩士學位。

剛畢業不久的赫斯勒已在紐約頗具影響力的空間舉辦過展覽，包括 Palo Gallery、O'Flaherty's 和 8-Ball Community。她的作品被秘魯、紐約和倫敦的私人收藏。

Road to Heaven
天堂之路

Acrylic, chalk pastel, pencil on canvas
布面丙烯、粉筆、鉛筆
26 x 28 in
2022

生生不息：
大地與城市的生態詩學

CIRCLE OF
LIFE:
ECOPOETIC

NG YEUT LAU
伍月柳

ZHOU TIANLI
周天黎

QI PENG
齊 鵬

YICK HANG
益 行

NINA PRYDE
派瑞芬

LILY HUI
許麗莉

MARGARET YEUNG
楊國芬

LAI YUK LIN
賴玉蓮

CHRISTINA CHEN
陳玉庭

"EXISTENCE · HER POWER"
THE TREND OF FEMALE ART

Art of Nature Contemporary Gallery Consultant

Clement Chan

Feminism has traditionally been divided into various waves, including liberal feminism, radical feminism, existentialist feminism, socialist feminism, postmodern feminism, poststructuralist feminism, etc. They signify different philosophical concepts and social ideologies. Unlike liberal feminism, which pursues opportunities for equality, socialist feminism emphasizes feminist and anti-capitalist struggle. A real female liberation must begin with the reform of family/marriage, private property rights, and religion in patriarchy, shattering social, physical, and religious decisive discourses. Liberal feminism stresses the dignity of both men and women and opposes to sex-determination system thus advocating equality for all. It believes the fundamental reason for gender oppression is the lack of access to education and fair competition with men.

Radical feminism strongly opposes to the sex-determination system. It asserts that men are inherently aggressive and violent and they exploit women's reproductive rights. The manipulation could be further developed into racial and hierarchical oppression. Radical feminists seek to abolish patriarchy by challenging existing social norms and creating a women-dominated society that will liberate everyone from an unjust society.

Postmodern feminism is also known as third-wave feminism, being deeply influenced by Jacques Derrida, Michel Foucault, Jacques Lacan, etc. It is featured as denials, doubts, vanishment, and destruction of essentialist views. The Queer Theory suggests that the male and female are socially constructed. There is no biological difference which is the variant of the power structure. According to queer theory, women must resist subtly to deconstruct patriarchy step by step. During the process, men and women are no longer enemies but care for and complete each other. The famous philosopher Judith Butler proposes that gender is performative which is fluid and flexible. Because gender identity is established through behavior, there is a possibility to construct different genders via different behaviors.

The development of feminism can be roughly divided into three stages. First-wave feminism was a period of activity during the 19th and early-20th centuries. It focused on the promotion of gender equality, citizen and political rights for women. Second-wave feminism occurred in the 1960s-1980s and aims at the elimination of gender differences. From the 1980s to nowadays, third-wave feminism - postmodern feminism faces up to gender differences without

pursuing absolute gender equality.

The title of Simon de Beauvoir's book *The Second Sex* refers to women's existence because of their subordination to men at all times. Undoubtedly, Men are the dominant first sex.

"Existence · Her Power", curated by Art of Nature team, is an international art exhibition that follows the historical trend of contemporary art, which enables everyone to examine, appreciate, explore, and reflect on the response of female art to inequities throughout the history, and the diverse possibilities as well as brand new aspects of female contemporary art expression.

「存在・她力量」
的女性藝術思潮

天趣當代藝術館顧問

陳偉邦

女性主義傳統上可分為多個流派，有自由主義女性主義、激進女性主義、存在主義女性主義、社會主義女性主義、後現代女性主義、後結構女性主義……等等，標誌著不同的哲學概念和社會意識型態。

有別自由主義追求機會平等，「社會主義的女性主義」流派特別強調女性主義的抗爭與反資本主義的鬥爭，真正的女性解放必然從男權社會中的家庭／婚姻、私有產權和宗教三方面著手，反對社會形態、生理和宗教形式的決定論。「自由女性主義」則強調男女都有人性的尊嚴，反對生理決定論，因而主張人人平等。女性受壓迫的根源在於缺乏受教育和與男性公平競爭的機會。

「激進女性主義」有強烈反抗生理決定論的色彩，男性生來就是侵略性和充滿暴力的，男性能利用這生理差異（例如：生育），來控制女性。這種壓迫甚至會衍生出其他形式的壓迫，例如種族和階級壓迫。要提升女性地位就必須追求徹底的變革，要必須建立一個新的女性掌權話語權和主導的社會。

「後現代女性主義」亦稱為「第三波女性主義」，深受德里達、福科、拉康等人的影響，以否定、懷疑、消解或摧毀所有本質主義的宏大理論體系著稱。其中著名的酷兒理論（Queer Theory）認為「男」和「女」這個概念只是社會文化建構出來，根本沒有男人和女人實際上的生理差異；又認為科學對男和女生理上的發現不過是權力建構的變體，女性必要用局部化「微抗爭」以發揮女性獨有的新話語權將男性霸權逐漸解構顛覆。最後主張在爭取婦女解放的過程中不再只把男性都看作壓迫女性的敵人，而是回歸關懷男性與女性相互依存關係。著名哲學家朱迪・巴特勒（Judith Butler）的表演理論徹底否定女性有所謂固定的社會及標籤化的性別（Gender）身份，主張身份是表演性的（Performed）、暫時的、不固定而有流動性的。

女性主義的歷史發展可簡略分為三個階段，第一階段是 19 世紀到 20 世紀中葉的自由女性主義時期，焦點是要求男女平等，主要是女性的公民權、政治權利等。第二階段是 20 世紀 60 年代到 80 年代的激進女權主義時期，目標是消除兩性差別。第三階段是 20 世紀 80 年代至今的後現代女性主義時期，回到強調兩性差異的客觀存在，不再一味盲目追求前階段的兩性平等。

西蒙波娃（Simon de Beauvoir）的女性主義大作《第二性》（*The Second Sex*）實指從屬的意思，意指女人一直以來都是作為男人的附屬而存在，而有第二性就有第一性，誰是掌權的第一性？答案則是呼之欲出。

天趣藝術人生基金會是次三月展出的大型「存在・她力量──國際當代女性藝術展」，就正承接著世界歷史及當代藝術的潮流，大家都可以藉此機會一同審視、欣賞、探討及反思女性藝術對於時代不平的呼應，和女性美學表現在當代藝術的不同可能性及嶄新面貌。

NG YEUT LAU

伍月柳

Ng Yeut Lau is a renowned painter, the third generation of the Lingnan School of painting. She is currently a member of the China Artists Association, an honorary academician of the Chinese University of Hong Kong, the Hong Kong Polytechnic University and S.H. Ho College of the Chinese University of Hong Kong, a council member of the Hong Kong Artists Association and the Hong Kong Painting, Calligraphy and traditional Chinese handicrafts, president of Hong Kong Lingnan Art Association and the Ling Ngai Art Association.

Ng has held solo exhibitions at Tsinghua University, Peking University, Beijing Central Academy of Fine Arts, Shanghai Art Museum, China Academy of Art, Guangdong Museum of Art, Guanshanyue Art Museum, Chiang Kai-Shek Memorial Hall, National Monument, Lingnan Fine Arts Museum, University of Dublin, Hong Kong Polytechnic University and the Chinese University of Hong Kong.

Ng's works have been widely collected by the Great Hall of the People, Diaoyutai State Guesthouse, Jingxi Hotel, Hong Kong Heritage Museum, Chiang Kai-Shek Memorial Hall, National Monument, Lingnan Fine Arts Museum, art galleries, and individual collectors.

Her artistic contributions and achievements have been widely recognized and praised internationally. In 2013, she received a special commendation from former Canadian Prime Minister Stephen Harper and Richmond Government, Toronto. In the same year, she was named one of the Outstanding Chinese. In her hometown Shaoguan, she was awarded honorary citizenship.

著名畫家，嶺南畫派第三代傳人，成就斐然。現任中國美術家協會會員、香港中文大學榮譽院士、香港理工大學榮譽院士、香港中文大學善衡書院榮譽院士、香港美協理事、香港書畫文玩協會理事、香港嶺南藝術會會長、嶺藝會會長。

曾於清華大學、北京大學、北京中央美術學院、上海美術館、中國美術學院、廣東美術館、關山月美術館、中正紀念堂、國父紀念館、中央研究院嶺南藝術館、愛爾蘭都柏林大學香港理工大學和香港中文大學等院校及藝術機構舉辦個人畫展。

作品獲中國人民大會堂、釣魚台國賓館、京西賓館、香港文化博物館、中正紀念堂、國父紀念館、中央研究院嶺南藝術館、藝術畫廊和個人收藏家廣泛收藏。

伍月柳在藝術上的貢獻及成就得到國際的認同及讚譽。2013 年，她獲加拿大前總理哈伯及多倫多列治文市政府特別頒發嘉許狀，同年當選為全球一百名傑出華人及世界傑出華人。在她的故鄉韶關，她獲授榮譽市民的美譽。

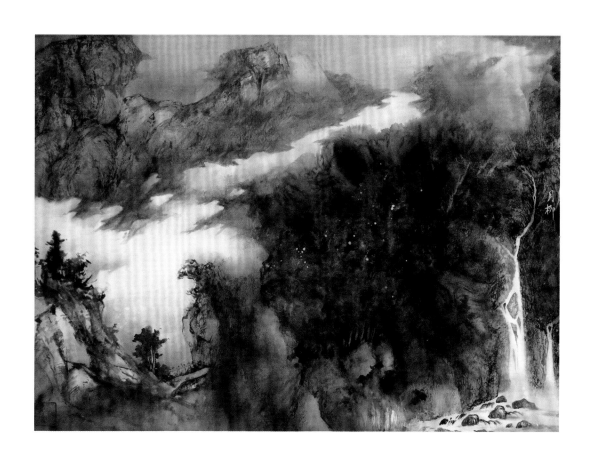

Mountains All with Autumn Red
秋來紅葉滿前山

Ink and color on paper
水墨設色紙本
67 x 92 cm
2022

周天黎

ZHOU TIANLI

Zhou Tianli is a well-known contemporary Chinese ink artist, art philosopher, and humanist. She was born in 1956 Shanghai, and now lives in Hong Kong.

The collections of paintings and essays that have been published include *Famous Artists Sketch Early Sketch Works of Zhou Tianli*, *Approaching Zhou Tianli Painting Collection*, *Artist Zhou Tianli*, *Zhou Tianli's Work Collection*, *Zhou Tianli's Spiritual Inquiry*, *Being for Thinking Chinese Painting's Soul*, *Zhou Tianli's Chinese Painting Research*, *Art and Philosophy*, etc. In June 2019, the TV featured film "On the Top of the LonelyPeak-Zhou Tianli's Painting" produced by Zhejiang TV was broadcast. She is a representative figure with greater influence in the Chinese art world.

　　當代中國著名的藝術家和藝術思想家、人文學者。1956 年出生，原籍上海，現居香港。

　　已經出版的畫集和文集有《名家手跡——周天黎早期素描作品》、《走近周天黎・畫集》《周天黎的藝術世界》、《周天黎作品・典藏》、《周天黎的精神追問》、《為思而在——中國畫魂周天黎》、《周天黎中國繪畫藝術研究》、《思想與藝術》等；2019 年 6 月，浙江電視台攝製的電視專題片《孤峰頂上——周天黎的繪畫藝術》播出。是中國美術界影響較大的代表性人物。

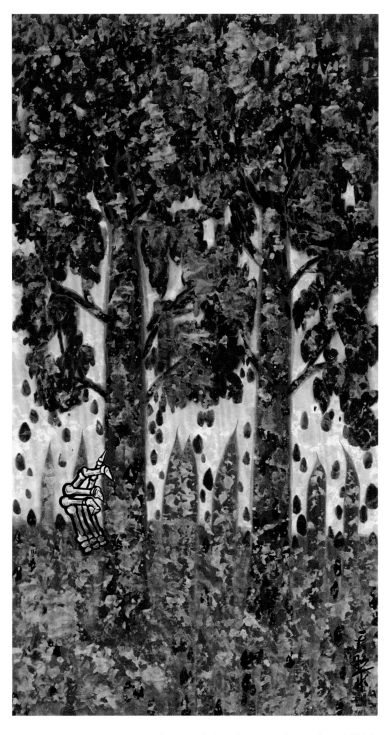

The Dark Blade - The Alarm of Fate 暗刃 - 命運之警
Ink and color on paper 水墨設色紙本
180 x 95 cm
2022

QI PENG 齊鵬

Qi Peng is the vice president of the Xinhua Painting and Calligraphy Institute, a researcher of the Wu Guanzhong Research Fellow Association in Tsinghua Academy of Fine Arts, member of the Chinese Artists Association and Hong Kong Artists Association. Qi has been recognized as a "scholar-painter" among art critics. She has received a silver award at the International Ink Competition and a national gold award for her thesis. She is the host of the national subject projects. Qi was awarded titles "Contemporary Artist", "Top 100 Influential Figures of Chinese Painting and Calligraphy", "World Chinese Meritorious Artist" etc.

Qi has held numerous solo exhibitions, including "Qi Peng Art Exhibition" in 1993, National Art Museum of China, "Qi Peng Art Exhibition" in1994, New York, "Symbol in China - Qi Peng Art Exhibition" in 2008, China National Academy of Painting, "Architecture Symbol - Qi Peng Art Exhibition" in 2010, Shanghai Expo - the UN Pavilion, "Louvre Chinese Painting Invitational Exhibition" in 2013,the 50th Anniversary of diplomatic relations between China and France, "A Song for Mother - Chinese Female Nomination Exhibition" in 2014.

新華書畫院副院長，中國美術家協會會員，清華美術學院吳冠中研究會研究員，香港美術家協會理事。國際水墨畫大賽銀獎獲得者，全國金獎論文獲得者，國家課題項目主持人，曾被授予「當代藝術家」、「中國書畫名家百佳影響力人物」、「世界華人功勳藝術家」等榮譽稱號。被藝術評論界認為是「學者型畫家」。

齊鵬曾多次舉辦個人畫展，包括「齊鵬繪畫作品展」（中國美術館，1993）、「齊鵬繪畫作品展」（美國紐約，1994）、「符號中國——齊鵬繪畫作品展」（中國國家畫院，2008）、「世博建築符號——齊鵬繪畫作品展」（上海世博園聯合國館，2010）。此外，還參加許多專題與主要展覽，包括「獻給母親的歌——2014年中國女畫家協會提名展」、2013中法建交50周年「法國盧浮宮中國畫藝術邀請展」等。

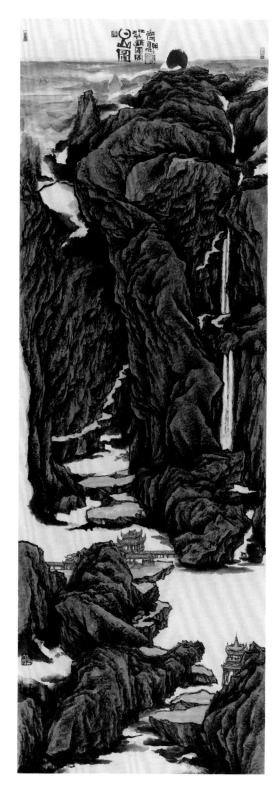

Diurnal Mountain
日山圖

Ink and color on paper
水墨設色紙本
200 x 68 cm
2013

益 行

YICK HANG

Yick Hang (Anne Tsui), born in Shanghai, graduated from Suzhou Art & Design Technology Institute in 1962, majored in Chinese painting, and was a student of Wu Yangmu and Fu Baoshi. She specialized in embroidering, brocading, and dyeing after graduating. She is also a columnist for several magazines and newspapers.

She is currently the director of the Chinese Ink Painting Institute of Hong Kong, vice chairman of the International Women Artists Association - Hong Kong and Hong Kong Art of Nature International Female Art Research Society, a member of the Hong Kong Artists Association and Hong Kong Culture Association, and a columnist for Master Insight.

Yick Hang participated in various ink exhibitions in Hong Kong, China, Taiwan, South-East Asia, Korea, Russia, and Europe. She held solo exhibitions in Sydney, Melbourne, and Hong Kong. Her artworks participated in Christie's' auction and widely collected by institutions and private collectors.

生於上海，年少時曾拜師吳養木、傅抱石等名家。1962 年由蘇州美專中國畫系畢業。曾是雜誌和報章專欄作家。

現任香港文化藝術交流協會副會長、世界女藝術家理事會香港分會及香港天趣國際女性藝術研究會副主席、中國畫學會香港理事、香港美協會員、香港文促會會員，目前為《灼見名家·益行遊藝》專欄作家。

曾參與內地、台灣、東南亞、韓國、俄羅斯等地的藝術交流展及全球水墨大展；亦在澳大利亞悉尼、墨爾本、香港舉辦個人畫展。其作品獲多個機構和私人收藏，及曾推薦佳士得拍賣。

Window of Memory
記憶之窗

Ink and color on paper
水墨設色紙本
135 x 68 cm
2016

NINA PRYDE 派瑞芬

Nina Pryde was born in Hong Kong in 1945. She began studying ceramics, sculpture, Chinese painting, calligraphy, as well as Western painting since the 1980s. She obtained advanced diploma in fine arts from the School of Continuing and Professional Studies, the Chinese University of Hong Kong in 2003. She obtained the certificate course in modern ink painting from the Hong Kong Chingying Institute of Visual Arts in 2005. Pryde completed the master of arts program in fine arts co-organized by the Royal Melbourne Institute of Technology University and Hong Kong Arts Centre's Hong Kong Art School in 2007. In 2008, she completed the certificate in fine arts - ink painting at the Hong Kong Visual Arts Centre and the Diploma in Chinese Calligraphy at the HKU School of Professional and Continuing Education in 2011. Pryde is now its honorary president of Hong Kong Modern Ink Painting Society. She is also a member of the Chinese Ink Painting Institute Hong Kong and the Hong Kong Artists Association.

Pryde has held various solo exhibitions since 2001, including "Reflections in Ink", Hong Kong Central Library in 2011, Hong Kong, "Fine Art Asia 2014", Hong Kong. "In Search of Idyll" in 2022, Illuminati Fine Art, Hong Kong. She also participated in many joint exhibitions held in Hong Kong and overseas, such as "The Valued and Revered Hong Kong Ink Art Invitational Exhibition", National Dr. Sun Yat-sen Memorial Hall, Taipei, "Ink Global 2021-2022", Hong Kong Central Library. Her works are also collected by the University Museum and Art Gallery of The University of Hong Kong, Oriental Mandarin Hotel, Landmark and various local institutions as well as private collectors, both at home and abroad.

1945 年生於香港，自八十年代開始先後修習陶瓷、雕塑、書法及中西繪畫；2003 年獲得中文大學專業進修學院西方藝術高等文憑；2005 年獲得香港正形設計學校現代水墨證書文憑；2007 年完成由澳洲皇家墨爾本理工大學和香港藝術中心香港藝術學院聯辦之藝術碩士學位課程；2008 年又在香港視覺藝術中心修畢藝術專修証書課程 - 水墨畫和 2011 年香港大學專業進修學院的中國書法文憑課程。現為香港現代水墨畫會名譽會長、中國畫學會香港和香港美術家協會會員。

2001 年至今曾舉辦多次個人展覽，包括「默墨迴響」（香港中央圖書館，2011）、「香港典亞藝博 2014」等，「玉階羅帷」（香港明畫廊，2022）等；亦積極參與多個香港及海外聯展，其中包括「墨尚香江 - 香港現代水墨邀請展」（台北國父紀念館，2019）、「全球華人水墨大展 2021 - 2022」（香港中央圖書館，2021）等。作品獲香港大學美術博物館、置地文華東方酒店，以及本地及海內外構和私人藏家收藏。

Crossroads
縱橫交鋒

Ink and color on paper
水墨設色紙本
134 x 203 cm
2016

許麗莉

LILY HUI

Lily Hui's works have been exhibited in China, Taiwan, Australia, Canada, Japan, South Korea, Macau, Russia, and Hong Kong. In 2013, she was honored with the Canadian Government's congratulations and awards for her solo exhibition in Ontario, Canada.

Hui currently is the permanent honorary president of Ontario Chinese Artists Association, the honorary president of Culture Way International Arts Association, the president of Yisu Association, member of the Hong Kong Society for Education in Art, president of International Women Artists Association - Hong Kong, executive committee of Xinyuan Art Group, member of the Hong Kong Artists Association, member of Calligraphy and Painting Study Association of Hong Kong Fukienese, member of Hong Kong Lan Ting Society, member of Hong Kong Sea Wave Art Association, and member of Qingqiu Art Association.

加拿大中國美術會永久名譽會長、文化通行國際藝術總會名譽會長、一粟書畫會會長、亞洲美術家協會香港特區副主席、世界女藝術家香港理事會會董、心源畫會執委、香港美協會員、香港福建書畫研究會會員、香港蘭亭學會會員、香港海濤彩墨會會員、青丘畫會會員。

作品曾在中國大陸、中國台灣、澳洲、加拿大、日本、韓國、澳門、俄羅斯和中國香港多處地區展覽。多次入選澳洲、日本、韓國國際邀請展。2013 年在加拿大安省舉行個展榮獲加拿大政府祝賀和嘉獎。

Zhangye Colorful Danxia Landform
張掖七彩丹霞

Ink and color on paper
水墨設色紙本
97 x 188 cm
2020

楊國芬

MARGARET YEUNG

Margaret Yeung graduated from the Fine Arts Department of the Chinese University of Hong Kong in 1985 and received a master's degree and a doctorate in Fine Art from RMIT University in 2004 and 2014 respectively. She has held various solo exhibitions and participated in joint exhibitions at home and abroad. Her artworks have been collected by the Shandong Museum, the Weifang Museum, the Jiangsu Art Museum, the He Xiangning Art Museum, the Taiwan Arts Education Center, etc.

She is currently one of the directors of the Hong Kong Modern Ink Painting Society, a member of the Hong Kong Artists Association, and a part-time instructor of the New Ink Painting Diploma Course of the School of Professional and Continuing Education at the Chinese University of Hong Kong.

1985 畢業於香港中文大學藝術系，2004 年及 2014 年分別獲澳洲皇家墨爾本理工大學藝術碩士及博士。

曾舉辦多次個展及參與多項海內外聯展，作品獲山東省美術館，濰坊博物館，江蘇省美術館，何香凝美術館，台灣藝術教育館等收藏。

現為香港現代水墨畫會會董，香港美協會員，香港中文大學專業進修學院「新水墨文憑課程」兼任導師。

Jubilee Landscape (I) 禧年山水（一）

Ink and color on paper, digital print on hahnemuhle rice paper
水墨設色紙本，藝術微噴
138 x 69 cm
2022

LAI YUK LIN

賴玉蓮

Lai Yuk Lin is the fourth generation of the Lingnan School of Painting under the mentoring of Ng Yeut Lau. She is currently the council member of the Guangxi Artists Association, the chairman of the Ling Ngai Art Association, the judge of HKYCAC, member of the Hong Kong Artists Association, council member of the Association of Overseas Chinese Artists, member of Hong Kong Lan Ting Society, member of the Shenzhen Female Artists Association, and the art instructor of Youth Artists Development Foundation.

Lai has participated in international exhibitions and competitions, including the "Shenzhen International Ink Painting Biennial" (2022), "The 2nd Global Ink Painting Exhibition" (2021), and won the Excellence Award in the "Dr. Shi Jingyi Cup - Chinese Painting and Calligraphy Competition" (2015), the Silver Award in "Meet in Hong Kong", and the 4th place in the Asia Pacific International Ink and Color Art League.

Her works have been exhibited at Tsinghua University, Peking University, Central Academy of Fine Arts, Fudan University, The Tokyo Metropolitan Art Museum, Chiang Kai-Shek Memorial Hall, National Taiwan University of Arts, Hong Kong City Hall, Hong Kong Central Library, Hong Kong Cultural Center, etc. Her works have been collected by the Great Hall of the People, Tsinghua University, Guangzhou Shixiang Garden, Foshan Shi Jingyi Liu Ziying Culture Art Gallery, and private collectors.

嶺南派大師伍月柳教授入室弟子，承嶺南畫派第四代傳人。現任廣西美術家協會理事、嶺藝會主席、全港青年學藝比賽評委、香港美協會員、海外中國美術協會理事、蘭亭學會會員、深圳女畫家協會會員、藝育菁英「大師承傳工作坊」中學組藝術導師。

多次參加國內外展覽及比賽，包括「時代含章深圳國際水墨雙年展」（2022）、「第二屆全球水墨畫大展」（2021），及獲「石景宜博士杯──華夏書畫創作大賽」優異獎（2015）、「中國書畫報社之相約香江」銀獎、亞太國際墨彩藝術聯盟第四名等。

作品在清華大學、北京大學、中央美術學院、復旦大學、日本東京都美術館、中正紀念堂、國立台灣藝術大學、香港大會堂、香港中央圖書館、香港文化中心等機構展出，部分作品為北京人民大會堂、清華大學、廣州十香園、佛山石景宜伉儷藝術博物館及個人收藏家所收藏。

Vientiane
萬象

Ink and color on paper
水墨設色紙本
148 x 120 cm
2021

CHRISTINA CHEN 陳玉庭

Chen Yuting, Christina, is an artist from Taiwan and lives in Singapore for 30 years. In 2004, Chen studied painting under Mr. Tan Khim Ser and also enrolled in the Nanyang Academy of Fine Arts in Singapore. In 2015, she attended the Chinese calligraphy at the Beijing Normal University of arts under Professor Ni Wendong, Wang Xueling, Zheng Peiliang, Fu Ruming etc.

She is currently, the president of the HK-Macau-TW Art Union in Singapore, honorary president of Singapore Life Art Society, honorary director of Singapore Federation of Art Societies, art advisor of Asia-Pacific Elite Entrepreneurs Association Contemporary, and art advisor the spokesman of the New Taipei City Private Purple Lotus Charity Foundation.

Chen has participated in numerous solo charity exhibitions in Singapore, Europe, and Taiwan, including the 2020 Art Taipei, the 2019 Art Expo Beijing, and the "Kaohsiung Calligraphy and Painting Association Exhibition". She also won the first prize in the "Gu Cao Xin Yun - Suzhou and Taiwan Young Artists' Painting Exhibition".

出生於台灣屏東，旅居新加坡 30 多年。2004 年師從陳欽賜先生習畫，並於新加坡南洋藝術學院進修藝術課程。2015 年入北師大藝術學院書法骨幹教師研修課程，師承倪文東、王學嶺、鄭培亮、傅如明諸位教授。

現為台灣港澳台美協新加坡分會會長，新加坡更生美術研究會名譽會長，新加坡美術總會名譽理事，亞洲傑出企業家協會當代藝術顧問，新北市紫蓮慈善事業基金會藝術顧問，新北市紫蓮慈善事業基金會公益代言人。

曾於新加坡，歐洲以及台灣等地區舉辦多次個人慈善書畫展，並參展 2020 台北藝博會、第 22 屆北京藝術博覽會，「高雄市書畫學會書畫展」「弘藝迴宙四人展」等。及於「古槽新韻‧千秋傳承／蘇台青年藝術家畫展」獲一等獎。

Butterflies will Congregate 1 - Red
花若盛開之一：紅墨

Mixed media
複合媒材
91 x 72 cm
2018

SHAPING MENTAL IMAGE: FABRIC AND ASSEMBLAGE

塑造心像：
織物與裝配藝術

GUO ZHEN
郭 楨

AYUMI ADACHI

HUANG MEI
黃 梅

XU DI
許 迪

LAU SIU SAN
劉肇珊

HANNAH HAN
韓 梅

IS THERE A NEED FOR THIS EXHIBITION TO EXIST?

President of German Promotion of International Exchange for Arts and Education (FiAKE)

Dr. Huang Mei

Under the leadership of Dr. Cissy Cheung, the Hong Kong Art of Nature International Female Art Research Society is dedicated to promote female artists. In 2015, the title of the art forum of *Infinite Love - The First Hong Kong International Female Contemporary Art Exhibition* was *Women Art on Sustainable Development of Humanities*, and I was invited to give an academic report on *the Sustainable Development of Global Female Art*.

After holding the second Hong Kong International Female Contemporary Art Exhibition in 2018, Art of Nature continued to devoted extra effort to organize online exhibitions of international female contemporary art in 2021. Particularly, in order to involve more international artists, I was invited to lead a team to promote the exhibition in Europe, inviting renowned international female artists, who areworking on the front line, to participate in the exhibition. We wanted to take this opportunity to enable audiences in Mainland China to continuously appreciate the diversity of global art creations comprehensively.

In 2021, the online exhibition received great attention. In 2022, the organizing team led by Dr. Cissy Cheung actively prepared for the offline exhibition even the epidemic was surging. When the epidemic is finally over in 2023, the offline exhibition *Existence · Her Power — International Female Contemporary Art Exhibition* is ready to "blossom" in spring.

The title of the exhibition "Existence · Her Power" implies a lot. First, women are half of the earth's population, and female artists also account for half or more of the total in the art field. But the chances for female artists exhibiting are far less than half, as for the good exhibitions are even less, and for the larger international exhibition events are even rarer!

"Existence · Her Power" is an advanced, precious opportunity for female artists. It come true by the effective efforts of Dr. Cissy Cheung and the organizing committee, as well as the dedication of all female artists, including myself.

This international art exhibition is a special "existence" showing female artists are united and impregnable. Thus, we hope to gain joint recognition and support from the society.

I am also honored to present an installation, photography and video synthesis in this exhibition.

In the 19th century, with the emergence of numerous inventions in the Industrial Revolution, science emerged frequently in life. The camera was invented which reproduced the beauty of nature and is much more accurate than the paintbrush. As a new art category, photography was born.

Conceptual art was born in the 20th century, and installation, performance and multimedia art started to develop since then. Western female artists also keep up with the time in creative means, media and concept innovation, to surpass men. In 2021, more than two-thirds of the works of Western female artists selected for the online exhibition are also photography, video, installation, and new media works.

The offline exhibition will showcase mostly paintings due to transportation issues. Works from international female artists will be impressive, active and vivid. This is not the end of art!

Finally, with my respect and appreciation, I sincerely wish the exhibition a great success!

這個國際展覽是「存在」的必然嗎？

德國藝術與教育國際交流促進會主席

黃梅博士

香港國際女性藝術研究會在張朱宇博士的領導下對推廣女性藝術家相當執著。2015年，天趣首屆「大愛無疆 —— 香港首屆國際女性當代藝術展」的學術論壇題目是「女性藝術促進社會人文的持續發展」，我應邀做了〈全球女性藝術的持續發展〉的學術報告。

在2018年舉辦了第二屆香港國際女性當代藝術展之後，天趣又在2021年開展全球女性當代藝術線上大展，並且投入更大的精力來將活動做得更加深入和更大規模。尤其是在參展藝術家的國際性方面，邀請我帶領一支團隊來更廣泛地直接在歐洲面向全世界宣傳這個展覽，挑選並邀請具有代表性的、正在創作第一線的、正當年的國際女性藝術家的作品參加這個展覽，並借此機會讓國內的藝術愛好者們能夠連續地、豐富地、全面地欣賞到當下世界各國與我們同齡的藝術家鮮活的創作。

2021年的線上展獲得了很大的關注，2022年，張朱宇博士領導的團隊在疫情嚴峻的時候積極準備線下大展。2023年疫情結束了，我們終於在春天裏迎來線下大展：「存在・她力量——國際女性當代藝術展」。

「存在・她力量」這個展覽名字蘊含了很多。首先，女性是整個地球人口一半的存在，從事藝術的女性也佔到從業人數的一半甚至以上。但女性藝術家參加展覽、被展出的機會卻遠遠低於一半，能夠參加好的展覽的機會又更少，能夠參加大型國際展覽的機會就更少，更少！

所以，「存在・她力量」是給女性藝術家一次高端的、難得的機會。這個機會的獲得要歸功於張朱宇博士團隊有效的努力，當然也有我們所有女性藝術家共同的奉獻，包括我本人。

這個國際展覽是表明我們女性藝術家團結不言放棄的一種特殊「存在」，希望獲得全社會的認可與支持。

此次展覽，作為藝術家我本人也榮幸地有一件裝置、攝影及影像綜合作品參展。

19世紀，工業革命新發明的大量湧現使得科學在人類生活中所佔的比重日漸提高，相機出現了，它再現大自然、再現人物的精準超過了畫筆，攝影作為一種新型的藝術門類誕生了，然後電影誕生了，影像藝術也應運而生。

20世紀觀念藝術誕生，裝置、行為、多媒體藝術初步強大。西方各國女性藝術家在創作手段、媒材、觀念的創新上也緊跟時代的步伐，並不落後於男性，2021年我們挑選出來的西方女性藝術家線上參展作品其中三分之二以上也是攝影、影像、裝置、行為、新媒體作品。

而線下展覽由於運輸問題還是繪畫佔主導。此次展覽上各個國家女性藝術家的繪畫作品將讓您耳目一新，以一件件讓人驚歎的作品展示繪畫還很活躍，沒有死亡。

預祝展覽圓滿成功！

郭 楨

GUO ZHEN

Guo Zhen is an artist and independent curator. She graduated from the Chinese Painting Department of the China Academy of Art in 1982 and stayed on to teach in the Chinese Painting Department. In 1986, she went to the San Francisco Art Institute to further her education. In 1987, she went to the York University College of Art as a visiting scholar. In 1988, she set up Guo Zhen's studio in New York. She is one of the earliest explorers of ink art after the reform and opening-up in China, and one of the pioneers of Asian American contemporary ink art. She has been committed to the research and exploration of international contemporary art for a long time. Her works can be seen in the international auction houses such as Sotheby's for various times.

　　藝術家，獨立策展人。1982 年畢業於中國美術學院國畫系並留校執教於中國畫系，1986 年赴美國三藩市藝術學院留學，1987 年赴加拿大約克大學藝術學院訪問學者，1988 年在紐約設立郭楨工作室。

　　郭楨是改革開放後水墨藝術最早的探索者之一，長期致力於國際當代藝術的研究和探索。蘇富比等國際大拍賣公司多次推動其作品。

Mother
母親

Cotton, silk
棉布 絲綢
225 x 900 x 30 cm
2016

AYUMI ADACHI

Ayumi Adachi was born in Hyogo, Japan in 1972. She studied at the Osaka University of art in Osaka, Japan. Ayumi lived and started creation in Hong Kong since 1996. She expresses multi-disciplinary media that works mostly with painting and large-scale installation. She is deeply inspired by nature and human life circulation with the concept of the time axis.Installation works introduce into the site and time specific with low-technical material, and paintings are by a sense of unique materials (paint on Mirror) and technique (combinate paint and carve).

She has several solo and group exhibitions in Hyogo, Osaka, Tokyo, Kanagawa, Kyoto, Niigata, Gunma, Shanghai, Hong Kong, Macau, Taiwan, Vietnam, France, India, Bulgaria and Portugal since 1992. Artworks have been exhibited at International art fair since 2010 and are in permanent collections by Four Season Hotel (HK), Shangri-la Hotel (HK & Tokyo, China) and Sheraton Hotel (China).

Ayumi's works are selected for The 24th Taro Okamoto Award for Contemporary Art, 2021 which selects 24 artists for the top historical competition in Japan.

Ayumi Adachi 1972 年出生於日本兵庫縣，於 1994 年獲得日本大阪藝術大學藝術學士學位。自 1996 年起常駐香港。她的作品主要以繪畫和大型裝置進行跨媒介表達。Ayumi 的靈感來自於時間軸下大自然和人類生活的循環，其裝置作品運用簡易的材料刻畫特定的地點和時間。她的繪畫大多使用獨特的材料 (鏡子上的油漆) 和技術 (油漆和雕刻的結合)。

Ayumi 自 1992 年便在兵庫、 大阪、東京、神奈川、京都、新瀉、群馬、上海、香港、澳門、台灣、越南、法國、印度、保加利亞和葡萄牙等地區舉辦過多次個展和聯展。

她的作品於 2010 年在國際藝術博覽會上展出，並被四季酒店 (香港)、香格里拉酒店 (香港和東京，中國大陸) 和喜來登酒店 (中國) 永久收藏。Ayumi 於 2021 年榮獲第 24 屆岡本太郎當代藝術獎。

ハレ ケ Hare Ke

Disposal article, black sewing thread, fabric (tamaki niime)
廢棄物品、黑色縫紉線、布料 (tamaki niime)
Installation is flexible size
尺寸多變
2023

HUANG MEI 黃 梅

Huang Mei is a curator, currently the President of the German Art and Education International Exchange Promotion Association and the host of mmae 720 Berlin.

Huang received her undergraduate degree from Peking University and master's degree from aesthetics master Li Zehou. She obtained her doctoratein art education from Frankfurt University.

Huang has curated exhibitions in prestigious venues around the world, such as the National Art Museum of China, the Shanghai Oil Painting and Sculpture Institute, the Today Art Museum in Beijing, the Helmhaus Museum in Zurich, the Museum of Art Lucerne, the Prague Exhibition Ground, and the Haus am Lützowplatz gallery.

She is also the author of the autobiography *Reflections, Love until Death*, which has been published in German, English, French, Russian and Greek and has attracted international attention. The English version published by Australia Heart Space Publisherin 2020, and the French version is under preparation by the French publisher.

自由策展人，現任德國藝術與教育國際交流促進會主席，主持柏林 mmae720 空間。

本科畢業於北京大學，碩士時師從美學大師李澤厚先生，德國法蘭克福大學藝術教育博士。

其策劃的展覽在世界各地著名場館展出，如中國美術館、上海油畫雕塑院、今日美術館、瑞士蘇黎世 Helmhaus 美術館、盧塞恩美術館、布拉格國際展覽中心、柏林 Haus am Lützowplatz 美術館。

著有自傳文學《向死而愛》，該書的德文、英文、法文、俄文、希臘文部分內容在相關國家文化界引起關注，2020 年該書的英文版由澳大利亞 Heartspace 出版社出版，法文版目前由法國出版社籌備出版中。

20000 +

Mixed media (Installation, video, photography, performance art)
綜合藝術（裝置、影像、攝影、行為）
2022

許 迪

XU DI

Xu Di is a professional artist. She studied at the Department of Sculpture, School of Fine Arts, Tsinghua University from 2004-2010 and received her bachelor's degree in 2008 and master's degree in 2010

Xu's works were selected for the 12th National Art Exhibition, and she was awarded the Gold Prize in the 3rd "Liu Kaiqu Award" International Sculpture Exhibition (2013) and the Excellent Prize in the 5th "Liu Kaiqu Award" International Sculpture Exhibition (2015).

Xu has participated in numerous solo exhibitions and group exhibitions at home and abroad, including "The 7th Stars Project Youth Contemporary Art Exhibition", "Blossoming Space - Invitation Exhibition of Chinese Artists" (Tokyo), and "Focus on China - Contemporary Art Exhibition" (Paris). Her works are collected by domestic and international institutions and private collections.

許迪，職業藝術家。2004 - 2008 年就讀於清華大學美術學院雕塑系，獲學士學位。2008 - 2010 年就讀於清華大學美術學院雕塑系，獲碩士學位。作品曾入選第十二屆全國美展，曾獲第三屆劉開渠國際雕塑大展金獎（2013年）、及第五屆劉開渠獎國際雕塑大展優秀獎並被收藏（2015 年）。

曾舉辦多次個展覽，及多次國內外群展，包括「第七屆繁星計畫——青年當代藝術大展」、「綻放空間——中國藝術家邀請展」（東京）、「聚焦中國——當代藝術展」（巴黎）。作品被國內外各大機構及私人收藏。

Observe Who You Are
觀想自心 - 你的樣子

Paper birch
白樺木拼接
81 x 66 x 99 cm
2014

劉肇珊

LAU SIU SAN

Lau Siu San is a film costume lecturer in Hong Kong. She obtained the master of arts in fine arts at the Chinese University of Hong Kong. Lau obtained the Bachelor of arts (Hons) degree from the Hong Kong Academy for Performing Arts in 2010, majoring in stage and costume design.

During her study, she was one of the scholars under the Hong Kong Jockey Club Scholarship Scheme. In 2016, she was awarded another Jockey Club scholarship for an immersive Executive Education program at Said Business School, University of Oxford. In 2018, "The Wise Athena" won 2 Winner Awards in the internationally renowned World of Wearable Art Award Competition.

設計學院戲服設計講師。2010 年獲得香港演藝學院文學士（榮譽）學位，主修舞台和服裝設計。現修讀香港中文大學藝術文學碩士課程。

在學期間曾獲得香港賽馬會獎學金。2016 年，她再得到賽馬會獎學金前往牛津大學賽德商學院接受高管教育課程。2018 年在國際著名的「可穿戴藝術獎」大賽中獲得兩項優勝獎。

Whispering Inside the Belly
肚子裡的細細話語

Installation
裝置
200 x 150 x 80 cm
2022

韓 梅

HANNAH HAN

Hannah Han is the chief designer of Ji Qing Tang. She graduated from Tokyo Designer Gakuin College majoring in furniture design. Her graduation design work won the best design award and has been collected by the school. From 2013 to 2018, her works were selected by Christie's private consultation multiple times. Two pieces of the 2018 series "She" were sold over the base price in Hong Kong Christie's 2018 Frist Open auction.

　　積慶堂首席設計師，畢業於日本東京設計師學院傢具設計專業，畢業設計作品「聆椅」獲最優秀設計獎，並被學校收藏至今。2013 - 2018 年，作品多次入選佳士得私洽。2018 年「她」系列兩件作品入選佳士得 2018 年 FRIST OPEN 香港拍賣並超出底價成交。

天鵝椅 II
The Swan II

Rosewood
花梨木
500 x 425 x 950 mm
2017

天鵝椅 I
The Swan I

Rosewood
花梨木
540 x 415 x 845 mm
2017

ODE TO A NEW ERA: IMAGINARY DIALOGUE THROUGH TIME AND SPACE

新時代頌：
穿越時空的影像對話

ROCHELLE YANG
楊宜瑄

CHEN YUNBING
陳贇冰

LAURA CAVANNA
勞拉·卡萬娜

CHONG NGO SHAN, AMY
臧傲珊

YU SHANMIN
于善敏

KWAN MEI SUI
關媄穗

WE MUST CONTINUE TO OVERCOME THE GENDER GAP

President of Association of Berlin Artists (VBK)
Sabine Schneider

I have been the president of the Verein Berliner Künstler (VBK) since 2007, which was founded in 1841. But it was not until 1990 that women artists were allowed to apply for admission and I was the first female president of the association.

After more than thirty years, two-thirds of the current 137 members are female artists. Since the proportion of male artists is less than that of female, a motion has been made to prioritize male applications, so that the proportion of male artists can reach 50% sooner.

But this proposal was rejected because there had always been more male artists than female. It is tiime to revese.

Experience has shown there are two main motivations for artists to join the association. The first is an interest in teamwork. The second is to expect to obtain more exhibition opportunities and develop professional contacts through the association. In recent years, more female artists have applied to join society than male, which indicates female artists need more support from society.

The art industry remains male-dominated, although there are plausible assumptions that male and female obtain the same opportunities.

However, just like many other professions, there is a gender gap existed in pricing. Normally, male work is recognized easier and can be priced higher without sufficient basis. Female creation is often considered unimportant, in terms of gallery pricing or the judgment of their perspectives.

Hence, to conquer the gender gap must show equal respect for male and female works which reflects inequalities. It should be illustrated by a change in public perception, particularly through special means of support, to improve the pricing of female artists and researchers in the art and labor market.

We must continue our efforts until equal opportunities for male and female are commonplace in arts and culture.

Art Life Foundation has been able to insist on international exchanges and support of female art, which is valuable. It is my great honor to participate in "Existence · Her Power" - International Female Contemporary Art Exhibition. I have been invited to China to participate in exhibitions for times. I hope to have the opportunity to participate in the exhibition for exchanges in Hong Kong in the future.

I wish the exhibition great success, thank you!

我們必須繼續努力
克服性別差距

柏林藝術家協會主席
薩賓娜·施耐德

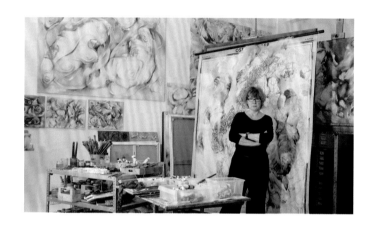

自 2007 年以來，我一直擔任柏林藝術家協會（VBK）主席一職，柏林藝術家協會（VBK）成立於 1841 年，但是直到 1990 年，女性藝術家才獲准申請進入該協會，同時我也是協會的首位女性主席。

經過三十餘年的變遷，目前 137 名成員中有三分之二是女性藝術家。由於男性藝術家在協會中的比例少於女性，有人提出動議，是否應該優先接受男性藝術家的入會申請，使得男性藝術家的比例盡快達到 50%。

但是，這個提議被否決了，理由是在歷史上曾經一直是男性藝術家的比例更大，為什麼現在女性藝術家不能比例大一點呢？

經驗表明，藝術家們申請加入協會的動機主要包括兩條，第一是有興趣加入團隊合作。第二是對協會寄予期望，比如通過協會獲得更多的展覽機會以及通過協會發展專業界的聯繫網路。近年來，申請加入協會的女性藝術家比男性藝術家多，這似乎表明了女性藝術家更需要協會的支持。

藝術市場仍然是一個男性主導的領域，儘管公眾形象方面的許多舉措可能會給人一種印象，即男性與女性藝術家已經存在著一種展示機會的平衡。

但是與許多其他職業一樣，尤其是在作品定價方面，存在性別價格差距。通常，男性藝術家的作品能夠更快獲得認可，沒有足夠的定價依據卻能賣出更高的價格。無論是在畫廊的定價方面，還是在對女性和男性視野評判的重要性方面，女性創作的題材世界往往被認為不那麼重要。

所以，克服性別差距，並對所有那些通過藝術創造，對我們複雜的社會作出認真反思的創造性的男性與女性藝術家的作品表示同等的讚賞與估值，這才是公平可取的。這應該反映在公眾觀念的轉變、特別是通過特殊的支持手段，實際改善女性藝術家以及研究者在藝術和勞動市場的定價。

我們必須繼續努力，直到女性與男性機會平等在藝術和文化中成為理所當然的事情。

香港天趣藝術人生基金會能夠堅持國際交流，支持女性藝術，難能可貴。我非常榮幸能夠參加「存在·她力量——國際女性當代藝術展」，我多次應邀去過中國參加展覽，希望今後有機會去香港展覽現場參加交流。

預祝展覽圓滿成功！

楊宜瑄
ROCHELLE YANG

Rochelle Yang is a cross-media visual artist, curator and international award-winning choreographer. Her artworks have been exhibited globally at many major art conventions, such as Nord Art (Germany), Shenzhen International Art Expo, Asia Contemporary Art Show, etc. Her latest animated film was selected for the 2021 Microwave International New Media Arts Festival.

Yang was awarded Honorary Doctorate in Arts, CISAC, France (The International Confederation of Authors and Composers Societies) and the Chinese Youth Award for Excellence (New York).

With her rich experience, Yang is the curator of SIGGRAPH Asia, moderator of the Greater Bay Area Conference of International Dance Council (UNESCO CID), and the reviewer of the Hong Kong Arts Development Council. Rochelle currently teaches at universities in Hong Kong, and serves as a director and program host for ArtMap / Art Plus.

跨媒體視覺藝術家、策展人以及國際得獎編舞家。其作品在世界各國展出，包括德國的 Nord Art、深圳國際雙年展、亞洲現代藝術展等。最新動畫影片入選 2021 微波國際新媒體藝術節。

曾榮獲法國著作權協會（CISAC）頒發的榮譽博士學位，紐約優秀青年獎。

豐富的產學經驗令其擔任亞洲 SIGGRAPH 數位藝術展策展人，聯合國舞蹈委員會（UNESCO CID）的大灣區會議主持人及香港藝術發展局審批員。目前在香港的大學任教、並擔任藝術地圖媒體董事及節目主持。

Flying Away Chaos
飛越混沌

Digital ink video
水墨影片
1'' / 2022

Flying Away Chaos is a short digital Chinese ink animation art film expresses fear and uncertainty during the pandemic. Splashes of ink and dark current symbolize the expansion of the virus. Flying across the ocean and clouds, the seabirds and goddess represent people's desires to free themselves from the global lockdown.

FLYING AWAY CHAOS
飛越混沌

《飛越混沌》是一部以水墨畫風格所製作的動畫藝術短片。反映人們面對疫情的恐懼和迷惘。墨水和暗流象徵著疫情的擴散,飛鳥和女神一同飛越疫海,表現出掙脫困頓的渴望,奔向寬廣的雲海中自由翱翔。

陳贇冰

CHEN YUNBING

Chen Yunbing obtained PhD from the Central Academy of Fine Arts and postdoctoral in Tsinghua University.

She is a member of China Computer Federation (CCF), member of Art and Artificial Intelligence committee of Chinese Association for Artificial Intelligence, member of CSIG Emotional Computing Committee.

Over the years, she has focused on the research of science and technology art, and has curated more than 10 contemporary new media art exhibitions. Her works have participated in important exhibitions such as the Asian Digital Art Exhibition. She is now the head of dream visualization at the Future Laboratory at Tsinghua University.

中央美術學院博士，清華大學博士後。

中國電腦學會會員、中國人工智能學會（CAAI）藝術與人工智慧專委會會員、中國圖像圖形學會會員、CSIG 情感計算專委會委員。

多年來專注於科技藝術的研究，策劃新媒體當代藝術展覽十餘場，作品曾參加亞洲數字藝術展等重要展覽，現為清華大學未來實驗室夢境可視化負責人。

Dream Visualization - Brain Dreaming Film
夢境可視化之腦機繪夢

Video
影像
2' 33"
2022

DREAM VISUALIZATION

夢境可視化

Dream Visualization — visualizing the hidden cognitive state of subconscious and unconscious, that is, using MRI and NIRS to monitor changes in brain activity and heat map to vividly visualize the cognitive activities during REM (rapid eye movement) sleep, to realize the abstract art form for dream visualization.In daily life, users can also carry out interactive painting through the dream visualization system, transforming the personalized EEG brain activities into unique artworks.

夢境可視化之腦機繪夢，即通過對夢境階段（REM 期）的腦電數據演算法設計實現夢境抽象藝術的可視化。在日常中，人們也可以通過腦機繪夢系統進行腦機交互繪畫，將個性化的腦電信號轉化成獨特的藝術作品。

勞拉・卡萬娜

LAURA CAVANNA

Laura Cavanna is an Italian architect with a strong focus in art and interior design, currently working in education. She is based in Hong Kong and has worked in many countries for various types of agencies and institutes, learning to appreciate and adapt to different aesthetics, preferences, and cultures.

Her work mainly focuses on lifestyle projects exploring new technologies and media. She strongly believes that communication, collaboration, and mentorship are an essential part of her work and she tries to communicate that through her research and projects.

　　勞拉・卡萬娜是一位專注於藝術和室內設計的義大利建築師,目前在教育領域工作。她常駐香港,曾在多個國家的機構和研究所工作,從中學習如何欣賞和適應不同的美學偏好和文化。

　　勞拉・卡萬娜的工作主要集中於探索新技術和媒體。她堅信溝通、合作和指導是工作的重點,並試圖通過她的研究項目傳達這一理念。

my
daughter's
face

AI Your Mind

Video
影像
2' 38"
2023

臧傲珊

CHONG NGO SHAN AMY

Chong Ngo Shan, Amy is a Hong Kong artist involved in painting, photography, and mixed media. She graduated with a fine art degree in RMIT University, which is associated with Hong Kong Art School and received Lens Based Art Form Award (WMA) in 2021.

Amy's works focus on lens-based mediums including photography and filming to present the social phenomenon of woman in Hong Kong. She believes the definition of female subjected arts will change in time and space. Amy's work becomes, ultimately, a philosophical and personal reflection on social and cultural norms.

香港藝術家，2021 年畢業於墨爾本皇家理工大學聯同香港藝術學院，獲藝術學士學位，並於 2021 年獲得 Lens Based Art Form Award (WMA)。當前從事繪畫、攝影和混合媒體工作。

臧傲珊的作品專注於以鏡頭為基礎媒體，包括攝影和拍攝，以探討香港女性主義的話題。她認為，女性主題的定義會隨著時間和空間改變，而她的作品最終將成為對社會和文化規範的哲學及個人反思。

24 / 7 Body Rental
24 / 7 出租

Video
影像
8′ 14″
2020

YU
SHANMIN 于善敏

Yu Shan Min obtained master of fine arts in filmmaking from department of filmmaking, National Taipei University of the Arts and master of fine arts in theater acting from department of Theater Arts, National Taipei University of the Arts, double master of music in choral conducting and vocal from Boyer College of Music and Dance (PA), Temple University, andvoice performance B.M. from Westminster Choir College.

Now she is the assistant professor at Shu-Te University Department of Performing Arts, the conductor and art director of the Shu-Te Glee Club, Tainan Chamber Choir, Culture Affairs Bureau Choir of Penghu County, and the art director and director of PLAY Theater.

Her film *Seen* was awarded the best public welfare film in the 3rd International Micro-Film Festival in China.

　　台灣藝術大學電影學系研究所電影創作碩士，台北藝術大學劇場戲劇系研究所表演組碩士，美國費城天普大學（Temple University）合唱指揮／聲樂雙碩士，美國西敏合唱音樂學院（Westminster Choir College）聲樂表演系畢業。

　　現為樹德科技大學表演藝術學系專任助理教授，樹德科大葛利合唱團、台南室內合唱團與澎湖文化局合唱團指揮暨藝術總監、PLAY 劇團藝術總監暨導演。

　　影片《看‧見》獲得第三屆中國國際微電影金微獎最佳公益片。

Bloom's Fantasy Wolrd
小布的異想世界

Video
影像
3'25
2022

關媄穗

KWAN MEI SUI

Born in Hong Kong, Kwan Mei Sui studied at contemporary ink artists summit program at the Shanghai Institution of Visual Arts under Mr. Liu Kuo-Sung. She owns the diploma of painting psychoanalyst, Doctor of Chinese Medicine (Neurosurgery), master of Chinese Law, and mater of Business Administration. Kwan has also won the Outstanding Chinese Award in 2020.She is currently the art advisor of the European Chinese Artists Association and the vice president of Hong Kong Art of Nature International Female Art Research Society.

Since 2008, she participated in more than 28 art exhibitions at home and abroad, whose works have been collected by various institutions and private collectors.

Influenced by Chinese culture and medical background, Kwan's works express strong traditional culture and a new perspective byenhancingmedical elements in art.

出生香港，曾於上海視覺藝術學院 - 當代水墨藝術研究院高峰班學習，師從劉國松。擁有繪畫心理分析師文憑，中醫學博士學位（腦神經外科），中國法律碩士，工商管理碩士，2020 年獲得傑出華人獎。現為歐洲中國藝術家協會藝術顧問，香港天趣國際女性藝術研究會副會長。

自 2008 年至今於國內外展出超過 28 場藝術展覽，作品為各大機構與私人收藏。

由於深受中華文化以及醫學背景影響，關媄穗的創作顯現出濃厚的傳統文化氣息，以及醫學元素加入提供的新的視角與趣味。

Beautiful Legend
美麗傳說

Digital ink
數碼水墨
68 x 38 cm
2022

I-DART: SPECIAL ART

愛而不同：
特殊展能藝術

LIU TUNG MUI
廖東梅

CHAN SZE MAN
陳詩敏

CHAN HIP YAN
陳協茵

WONG SAU LAN
黃秀蘭

CHENG KA YAN
鄭嘉恩

LO SIU KUEN
盧少娟

MINNA CHAN
陳曉妍

CHEER FOR WOMEN IN ARTS

"Existence · Her Power" Specially Invited Curator
Guo Zhen

Artists, like all people, are individuals and also exist as part of a group. The lives and experiences of female artists will not be isolated. Like their male counterparts, the source of all their experiences, feelings and inspirations must have soil, environment, and content; and these sources cannot be separated from the social groups in which they lived.

During the feudal era, Chinese women were socially and culturally confined and restricted, and the scope of women's lives was narrow and low. Art by women was kept in obscurity and were classified by society as the realm of boudoir culture, playful art. Theri works were not taken seriously. In the history of the Chinese arts, there is virtually no record of art by women, and particularly so in the history of painting, where only a handful of female artists are recorded. Until now, few people have systematically explored the status and significance of women in the history of Chinese painting. During the period of the Republic of China, several women set precedents in art, but not only were they given no academic research and exploration, but instead were degraded by the existing male hierarchy.

Since the reform of China, more and more women have chosen art as a career, and now women outnumber men in art schools, but there are still few women on art's honor rolls. Why has there never been a recognized female master of ink? Is it the social denigration of women's thoughts that is at work? Is it because of a decadent feudal consciousness that disparages women's wisdom and achievements? Or is it society's foolishness and deafness to women's self-awareness?

Feminism advocates equal social status and rights for women and promotes women's independence and creativity. After years of struggle, the role and status of women in societies around the world has become increasingly important, and the international community has become more aware and serious about women's issues.

The emergence of feminism has also contributed to the development of women's art. It is encouraging and gratifying that 80% of the works exhibited at the 2022 Venice Biennale were created by female artists. In contrast, Asian female art has yet to define its place and role. Asian women artists have little academic research on international art platforms, and there is no critical archive on women's art. As a result, this art has at best a small audience and a narrow market. Asian artists are still searching for their identity, and the road to recognition remains long and difficult.

Artistic talent and creative ability are not inherently male or female, but social prejudices stifle one side. In fact, women in art are equally sensitive, equally profound, equally pleasing to the eye, equally chasing, and equally in their own order. The rise of women today is multifaceted and will certainly be present in art, so it is especially important to look deeply into the influence of women in contemporary art.

An art exhibition requires a tremendous unseen work until the opening, or rather, until the end of the exhibit. From picking a title, locating a venue, copywriting, to choosing the artists, selecting artworks, transportation, installation, promotion, and so on. Also, an exhibition needs financing to support a serious academic exhibition, because these lack the support of the market. There are many difficulties in producing a serious exhibition nowadays, and it is especially difficult to make a women's art show. Women's art is still neglected, seen as unimportant, a "niche," and outside of the mainstream, thus making it more difficult to find adequate funding.

I find it invaluable that the Art Life Foundation and the Hong Kong Art of Nature International Female Art Research Society are hosting "Existence · Her Power — International Female Contemporary Art Exhibition" an extraordinary exhibition of women's art.

We look forward to this exhibition. Expect to viewing the excellent works of outstanding international women artists, waiting to see the response of the Hong Kong community. We wish the art market pay more attention tower to women artists and hope to see the release of sincere critical essays on women's art.

為女性藝術喝彩

「存在・她力量」特邀策展人
郭 楨

人以個體而呈現，以群體而存在，女性藝術家的生命體驗也不會是孤立的。她們與男性藝術家一樣，所有的體驗、感悟和靈感的來源，一定是有土壤、有環境、有內容的。而這些土壤、環境、內容等等的來源離不開其生存的社會群體。

在封建時代，中國女性社會群體是被禁錮封閉的，女性的生活範疇狹窄低下，女性的藝術創作一直處於遮蔽的隱秘之處，被社會劃規為閨閣文化之領域，是被玩味的藝術。綜觀中國藝術史，基本沒有對女性藝術的記載，就是在繪畫史中，被記載下來的女性藝術家也寥若晨星，所以直到現在也少有人系統地探討女性在繪畫史中的地位和意義。上世紀民國期間的幾位新女性開創了女性藝術的先河，但是不僅沒有給予她們學術上的研究和探討，相反被低俗的人們貪婪地消費她們的苦難和私生活。

改革開放之後，愈來愈多的女性選擇藝術為職業，現在藝術學院裏女性普遍多於男性，但在社會的藝術榮譽榜裏卻依然鮮有女性在例。我們不禁會問：是歷史上從來就不存在女性墨主嗎？還是社會對女性意識的遮蔽在作崇？是封建的腐朽意識對女性智慧的詆毀？還是女性自我意識的愚弱失聰？

女性主義提出要女性平等的社會地位和權益，提倡女性的獨立性及創造性。經過多年的抗爭，女性在世界各國的社會生活中所扮演的角色與地位日趨重要，國際社會對女性問題也更加關注和認真對待。

女性主義的出現也促進了女性藝術的發展。值得一提的是 2022 年的威尼斯雙年展，參展作品竟有 80% 是女性藝術家創作的，令人鼓舞和欣慰。相比之下，亞洲女性藝術還沒有確定自己的位置和角色。亞裔女性藝術家在國際藝術平台上沒有學術研究，也沒有關於女性藝術的批評檔案館。因此，它的觀眾很少，藝術市場也很狹窄。藝術家們仍在尋找著自己的身份，然而獲得認知的道路是漫長而艱難的。

我們應該明確的是，藝術天分和創造能力本無男女之分，但是社會偏見扼殺了一方。事實上，女性在藝術中是同樣敏感，同樣深邃，同樣悅目，同樣馳逐，同樣具有自己的次序。當下女性的崛起是多方面的，也必將呈現在藝術上，因此深入觀察和研究女性在當代藝術中的影響和位置尤為重要。

一場展覽的呈現是需要過程的，在這個過程裏有很多看不見的工作在進行著，一直到開幕，或者說一直到展覽結束。例如：選題，策劃，文案，到選擇藝術家，選擇藝術作品，運輸，裝置，宣傳等等。一場嚴肅的學術展

覽的運作需要很多資金去支撐——因為學術展覽缺少市場的支撐。所以在當下做一場嚴肅的展覽有諸多困難，女性藝術展則更加不易，女性藝術仍然是被忽略的，被視為不重要的，是小眾的，是不在主流藝術範圍的……因此就更難找到支持資金。

因此這次天趣藝術人生基金會和天趣國際女性藝術研究會舉辦的「存在・她力量」—— 國際女性當代藝術展就更難能可貴，這是一場很有選擇性的女性藝術展覽，是為支持和推廣女性藝術做的歷史意義的活動。

我很期待這次展覽的呈現，期待看到眾多優秀國際女藝術家的優秀藝術作品，期待看到香港社會對此的反應，期待藝術市場女性藝術家的關注，期待真誠的女性藝術批評論文的發佈。

廖東梅
LIU TUNG MUI

Liu Tung Mui was born in Beijing in 1974 and has been motor impaired from birth. She moved to Hong Kong in 1999 and has been actively involved in art exhibitions and competitions both at home and abroad.

She has received numerous awards, including the 1st runner-up of "the 5th International Abilympics (Prague)" Poster Design Competition in 2000, "Ten Outstanding Young Persons Selected" in 2000, "The Most Successful Women" by JESSICA in 2007 and "2012 Hong Kong Spirit Ambassador".

Her works have been exhibited in Japan, the USA, France, the Czech Republic, Macau and other countries and regions. Murals designed with her work have been displayed at the Hong Kong Airport and MTR.

特殊展能藝術家。1974 年生於北京，出生時因缺氧換腦筋攣至今。自學繪畫，1999 年移居香港，積極參與海內外藝術展覽及比賽。

廖東梅曾獲諸多獎項，包括第 5 屆國際展能節海報設計亞軍（2000），香港十大傑出青年稱號（2000），《旭茉 Jessica》雜誌成功女性獎（2007），香港特區政府頒授榮譽勳章（2007），香港精神大使稱號（2012）。

作品在日本、美國、法國、捷克、澳門等多個國家和地區展出。香港機場與地鐵亦曾展示以她作品設計的壁畫。

Dance Path No. 3
舞跡系列（三）

Ink and color on paper
水墨設色紙本
82 x 160 cm
2015

陳詩敏
CHAN
SZE MAN

Chan Sze Man, Vicky has participated in various local and overseas exhibition, including "Asia Contemporary Art Show" in 2014, "Trans Pacific Ties Bridging Hong Kong and Los Angeles Through Art" in 2014, "Big-I Art Project" in 2016, and "Da Xi Di Art Exhibition at Taipei 2017".

Chan is good at using lines to sketch landscapes boldly, with interesting appearances and clear composition. Her artworks have been selected for various designs such as the paddle design of Hong Kong International Dragon Boat Races in 2017, gift by Shell Hong Kong (2018), the design of postcard by Hotel 181(2019) and picture book (2020).

特殊展能藝術家。曾參與國內外多個展覽活動及藝術項目,包括「亞洲當代藝術展 2014」、「藝聚雙城:香港 X 洛杉磯聯展」(2014)、「日本 Big-i Art Project 2015」、「台北大嘻地公益藝術互動創作展」等。

陳詩敏擅於運用大膽的線條去勾畫景物,型態有趣,構圖分明。作品亦受邀運用於各類設計,如受邀為香港國際龍舟邀請賽 2017- 巨型龍舟槳設計,香港蜆殼禮品設計(2018),One-Eight-One 酒店明信片設計(2019),「我在家裡做什麼?」抗疫繪本設計(2020)。

Spiritual Leaves
心靈樹葉

Acrylic on canvas
布面丙烯
49 x 99 cm
2018

陳協茵

CHAN HIP YAN

Chan Hip Yan's artworks are selected for Art Competition for Social Inclusion, "Big-I Art Project 2017", "Art work selected in Cross All Borders: Hong Kong Festival Showcasing New Visual Artists with Disabilities 2018 – Open Division", "The Nippon Foundation DIVERSITY IN THE ARTS International Art Competition 2018 – Overseas Works Award".

She chooses the magazine pages in a self-directed manner. She reads the visual images and selects which materials and colors to paint, then decides what and how to cover/re-create. When she keeps an individual object or the outline of a figure intact, it is intriguing. An atmosphere of mystery and stillness is created by the dense lines and rough texture.

　　特殊展能藝術家。曾入圍「社創 SoIN：無障畫創大賽」。並曾參與國內外多個展覽活動及藝術項目，包括「日本 Big-i Art Project 2017」、「藝無疆：新晉展能藝術家大匯展 2018」、「日本財團 DIVERSITY IN THE ARTS 公募展」（2018）等。

　　陳協茵以獨特的形式進行創作──用鮮明對比且堅實的色彩遮蓋印刷刊物，重新繪製成獨特的視覺影像。有時或保留個別物件、人像原型，更耐人尋味；綿密的線條加上粗糙的質感營造神秘、寂寥的氛圍。

PN	1969 - 70
Crayon on paper	Crayon on paper
紙本彩蠟	紙本彩蠟
30.5 x 21.5 cm	30 x 21.5 cm
2020	2020
Pool Shooting	Blue Man
泳池拍攝	藍色男人
Crayon on paper	Crayon on paper
紙本彩蠟	紙本彩蠟
30.5 x 21 cm	30 x 20.5 cm
2020	2020

黃秀蘭

WONG SAU LAN

Wong Sau Lan graduated at i-dArt 2nd Art Course (4-Year). She was awarded the Companionship at the Best Creativity Award in "Cross All Boarders 2022" organized by Arts with the Disabled Association Hong Kong. Her artworks were selected in "Big-I Art Project in 2017", and "i-dArt The 2nd Art Course (4-Year) Annual Show@ Cattle Depot Artist Village".

Her deformed portrait has a weird appearance and the subtle facial expression reveals a strange feeling, showing her anxiety. The short lines as well as the unimaginable color mix carry an atmosphere of tension and anxiety in the paintings. For this reason, painting can let her put down her anxiety on the drawing paper and keep her in peace.

　　特殊展能藝術家。畢業於「愛不同藝術－第二屆藝術課程（四年）」，作品曾獲香港展能藝術會主辦「藝無疆 2022」之最具創意獎。並曾參與國內外多個展覽活動及藝術項目，包括「日本 Big-i Art Project 2015」、「愛不同藝術第二屆藝術課程（四年）年度展」等。

　　黃秀蘭創造的人像辨識度高，變形的人像有著詭譎的外貌，微妙的面部表情流露奇特的感覺，呈現出她的焦慮感，不安的氛圍被統合於有條不紊的構圖中，取得恰到好處的平衡。

Still Painting
靜物畫

Color pencil on paper
紙本馬克筆
41 x 50 cm
2019

鄭嘉恩
CHENG KA YAN

Cheng Ka Yan has held solo exhibition "Hong Kong Picture - CHENG Ka-yan Paper Art Collage Exhibition" in 2015. She participated in "Asia Contemporary Art Show " in 2015, artwork selected in "SPARK Festivalin 2015", and "International Exhibition for Disabled People", Wuhan in 2017.

Cheng's favorite themes are words from advertisements, portraits of historical figures or characters from legends as well as buddhas. Ka-yan also does another creation: paper-cutting. She keeps piles of these terms in her mind. She cuts the terms out from paper and presents them before us in rich and bright colors. What we see is the memory of an era in Hong Kong.

特殊展能藝術家。曾舉辦個展「香港風情畫 – 鄭嘉恩剪紙展」，並曾參與國內外多個展覽活動及藝術項目，包括「亞洲當代藝術展 2015」、「加拿大 SPARK Festival」（2015）、武漢「第二屆融合‧國際殘疾人藝術展」等。

鄭嘉恩喜歡繪畫廣告文字、佛像與人像，而人像則多為古人與傳說人物。除繪畫外，她的創作媒材還包括紗織與剪紙拼貼等。鄭嘉恩在此次展出的剪紙拼貼系列作品展現了豐富的色彩，從中我們能看到一個時代的香港記憶。

On the Water Side
在水一方

Collage
顏色紙剪貼
43 x 59 cm
2000

盧少娟

LO
SIU KUEN

Lo Siu Kuen graduated at i-dArt 2nd Art Course (4-Year).She was awarded The Nippon Foundation DIVERSITY IN THE ARTS International Art Competition 2019 – Emi Zouza Award. She participated in Asia Contemporary Art Show in 2017, Paintscape – An Exhibition of Works by Artists with Disabilities in 2019, Art Macao: "Three slices of Life – Joint Art Exhibition: Japan, Hong Kong & Macao" in 2019. She has also done illustration for feature article at Sunday Mingpao.

She loves painting portraits, landscapes, apparel and daily articles. Each forceful stroke left a trace in her artworks without hesitation. Dense lines were closely placed to each other. The contrast among colors was big and even unconventional.

特殊展能藝術家。畢業於「愛不同藝術 - 第二屆藝術課程（四年）」，作品曾獲日本財團「DIVERSITY IN THE ARTS 公募展2019」評審大獎「藏座江美獎」，並曾參與國內外多個展覽活動及藝術項目，包括「亞洲當代藝術展2017」、「畫景 – 展能藝術家作品聯展》、「三種日常 - 日港澳藝術聯展」等。 另外曾為星期日《明報》專題「七情上面」繪畫插圖。

盧少娟的創作風格大膽鮮明，選色野性奔放，形成強烈對比的視覺效果。較常用乾性顏料，如鉛筆、油粉彩或箱頭筆等，且作畫主題多元，包含人像、時裝、風景、動植物等。

請多謝幫助帶女愛好人 照片5人入行送給我配給他其姓名快有來自己盧少娟

The Comic Girls
漫畫少女

Color pencil on paper
紙本馬克筆
38 x 29.5 cm
2018

陳曉妍

MINNA CHAN

Minna Chan has been diagnosed with speech and language impairment and high-function autistic spectrum disorder. She started to paint when she was 3-year-old. In 2013, she won the championship of the junior group of the third International Youth Competition. In 2018, she was the youngest participant in the "Because of Love – A Female Contemporary Art Exhibition". In 2022, she graduated from the MBA University of Management & Technology, USA.

特殊展能藝術家。先天患有語言障礙和自閉症，自三歲開始學習繪畫，於 2013 年贏得第三屆國際少年大賽少年組冠軍，2018 年以最年輕女藝術家身份參展「憑著愛——當代女性藝術展」，2022 年獲得美國管理及科技大學碩士學位。

Reunion-Family
重逢 - 親情

Acrylic on canvas
布面丙烯
50 x 60 cm
2022

PARTICIPATING ARTISTS

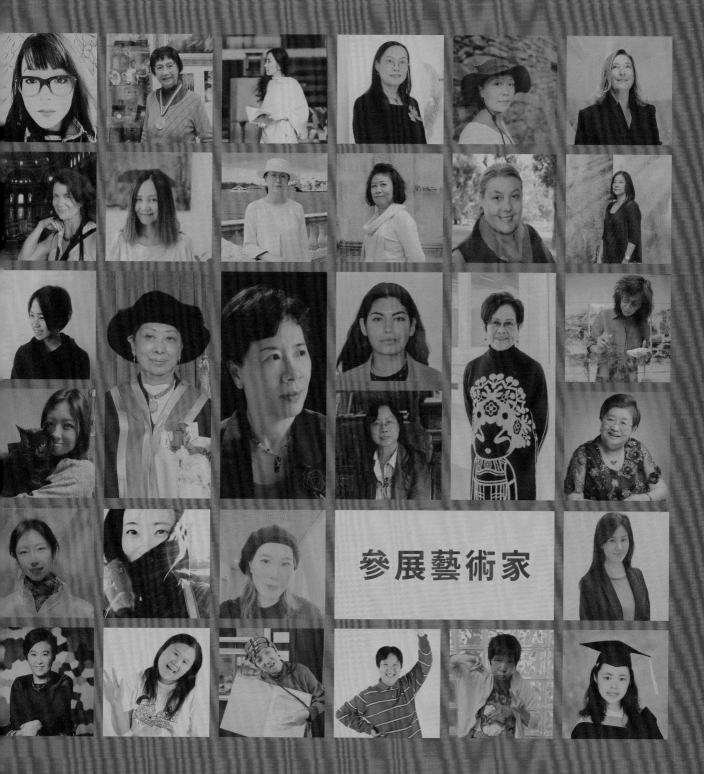

參展藝術家

總策展人語

AN AFTERWORD BY CHIEF CURATOR

EXISTENCE OF HER POWER

Founder of Art Life Foundation and Curator

Dr. Cissy Cheung

If we look at the history of art, we will find that there were very few great female artists. But in fact, there have been a number of female artists in history who were extremely creative in art and had profound influence towards future generations. They are often overwhelmed by prejudice and forgotten by the history, and female art has always faced the plight of absence and marginalization.

Fortunately, with the development of feminism, female art and female artists have been on the rise in the past few decades, and they have gradually voiced their thoughts and bloomed in the academic circles and art market. For more than ten years, we have been working with a group of international promoters and making great efforts to contribute to the promotion of women's art. It is hoped to establish a female art platform that allows women to shine, establish their professionalism as well as commercial value and influence. More outstanding female artists would have the opportunity to express, create, and be seen.

Looking back to the Gwangju Biennale in South Korea in 2018, the International Women's Art Union proposed to hold an exhibition in Hong Kong in 2021. During the Moscow International Women's Art Union Exhibition in 2019, it was confirmed that we would be the host of the "International Women's Art Exhibitionin Hong Kong in 2021". During the preparation period, the global outbreak of coronavirus pandemic caused our planning to fall into a state of hesitation. However, it gave us more time to think about the importance of the existence of female art.

Female artists have their unique "existence structure" and "existence mode" in the society. They use their works to project their innermost self, to find the value of self - identity and self - existence, to explore the meaning of women's life, and to establish women's independent narrative space. The power of "her" has always existed and continued to develop and advance because people are prompted to think about the ideal "state of existence" of women and how to construct an ideal world of equality and harmony. This is the origin of the "Existence · Her Power" exhibition.

Although the exhibition was not held as scheduled in 2021 in Hong Kong, we never fell behind with the progress. We built the "Her Art" platform in the end of 2020, and took the lead in launching "Her Power" - an online exhibition of global contemporary women's art during the International Women's Day in 2021. With the joint efforts of co-curators from all over the world, the exhibition launched a total of 30 topics, exhibiting thousands of works by more than 300 outstanding artists from more than 50 countries and regions around the world. Under the pandemic situation, female artists from various countries supported and encouraged each other throughout the online exhibition. This is the background of the "Existence · Her Power" exhibition.

With the original goal of promoting women's art and the support of the Hong Kong Arts Development Council, "Existence · Her Power — International Female Contemporary Art Exhibition" would be officially launched on 24 March 2023. A series of charitable public activities such as academic forums, art lectures and art salons would also be held. The exhibition is the continuation of the "Infinite Love exhibition" series. The first series was the "Infinite Love - The First Hong Kong International Female Contemporary Art Exhibition" held in 2015 and the second series was the "Because of Love - Female Contemporary Art Exhibition" held in 2018. Existence · *Her Power* would be the third series.

The current exhibition takes "academic and love" as the core of the exhibition, presenting multiple ways of creative expression and art styles from different ethnic background. Divided into 6 themes, it presents more than hundred works of oil paintings, ink, installations, videos, multimedia synthesis, sculptures and new mediafrom outstanding female artists of various countries and regions around the world.

We ART women. We ART together! It is expected that in this exhibition, we can explore women's multi-dimensional creativity and mind-set of various cultures and ages through their expression in arts. The exhibition also provides an opportunity for female artists to reflect on current social culture or personal issues, and research on the possibility of female aesthetics in contemporary art. Let's work together and make women's art blooms continuously!

I would like to express my gratitude to all the participating artists, the expert advisory group for providing academic support for the exhibition, and the academic institutions, media and entrepreneurs who sponsored and supported this event. Finally, I would like to express my heartfelt thanks to the curatorial team and all volunteers who have paid great efforts for the exhibition. I always believe that if we keep the enthusiasm and passion for art, art will endow us with youth, meaning and value. I firmly believe that the energy generated by our burning hearts for art is the power that is incomparable to any other!

她力量的存在

天趣藝術人生基金會創辦人及總策展人

張朱宇博士

打開藝術史，我們會發現鮮有偉大的女藝術家。但其實歷史上存在為數不少繪畫藝術極具創造力並深刻影響後人的女性畫家，只是她們往往被偏見淹沒、被歷史遺忘，女性藝術也一直面臨缺席和被邊緣化的困境。

幸運的是，伴隨著女性主義的發展，過去幾十年裏女性藝術與女性藝術家們不斷在崛起，她們逐漸在學術界、市場，發出聲音，綻放力量。這十多年來，我們一直與國際上一批推動者，不遺餘力為女性藝術的傳播與推廣貢獻力量。希望通過建立一個讓女性綻放光彩、展現專業、兼顧學術與商業價值和影響力的女性藝術平台，讓更多優秀的女性藝術家有機會表達、創作，及被看見。

回望初始，2018 年韓國光州雙年展期間，國際女性藝術聯盟會議提出 2021 香港展的動議，並在 2019 年莫斯科的國際女性藝術聯盟大展期間，確定了 2021 年我們作為東道主在香港舉辦國際女性藝術大展。籌備期間，一場席捲全球的肺疫令籌畫陷入了躊躇不前的狀態。但這也讓我們有更多時間去思考、整理關於女性藝術存在的意義。

女性藝術家在社會中有著自身獨有的「存在結構」和「存在方式」，她們用作品投射出內心，尋找自我認同與自我存在的價值，探尋女性的生命意義，建立女性自主的敘述空間。「她」力量之所以一直存在並不斷發展、前進，是因為自由的生命在不斷地跳躍，將自我的力量歸還於生命本身，不斷引發人們去思考女性理想的「存在狀態」，以及如何構建兩性平等和諧的理想世界。這即是展覽名稱「存在·她力量」的起源。

俄羅斯香港展的約定，雖然受疫情影響，令我們無法在 2021 年如期舉辦，但我們的步伐從未停滯。我們在 2020 年底搭建了「她藝術」平台，並於 2021 年國際婦女節率先發起了「她力量」——全球當代女性線上展。在全球各地區聯合策展人的共同努力下，展覽共推出 30 個專題，展出全球 50 多個國家和地區 300 百多位優秀藝術家的上千件作品。這場疫情下的國際展覽深入推進過程中，各國女性藝術家之間互相支持、彼此激勵，「存在·她力量」便在此背景下醞釀而成。

懷著推動女性藝術的初心，在香港藝術發展局的支持下，「存在·她力量」——國際女性當代藝術展將於 2023 年 3 月 24 日正式啟動，同期將舉行學術論壇、藝術講座、愛心公益、藝術沙龍等一系列慈善公益活動。同時亦作為天趣女性藝術展品牌「大愛無疆」的延續，是繼首屆「大愛無疆」（2015）、第二屆「憑著愛」（2018）後的第三屆「大愛無疆」系列展。

本次展覽以「學術及關愛」為展覽核心，呈現多元創作表達方式及多民族的女性藝術面貌。並分六個主題，呈現來自全球數十個國家及地區的優秀女性藝術家的油畫、水墨、裝置、影像、多媒體合成、雕塑、新材料等過百件作品。

We ART women. We ART together！期待本次展覽能夠通過跨國界、跨文化、跨年齡的優秀女藝術家極具個人特色的作品，探索她們在力量與表達間碰撞出的多元色彩與思考；呈現女性意識的吶喊，女性視角下對於當下社會文化或切身問題的省思；以及研究女性美學表現在當代藝術中的可能性。令生命影響生命，以力量激發力量，讓充盈著生命之光的女性藝術不斷綻放！

在此衷心感謝所有的參展藝術家，感謝為展覽提供學術支援的專家顧問團，感謝贊助支持本次活動的大專院校、媒體機構及企業家們。最後，衷心感謝為展覽努力了數百日的策展團隊及全體義工團成員。我始終相信，當我們對藝術保持永不間斷的熱情和激情，那麼藝術就賦予了我們生命的青春、意義和價值。我堅信，我們共同為藝術而燃燒的心所產生的能量，是任何其他都不可比擬的「她力量」！

主辦機構

THE ORGANIZER

ABOUT ART LIFE FOUNDATION
天趣藝術人生基金會簡介

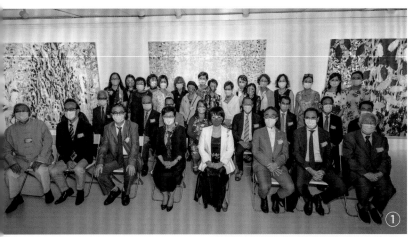

Art Life Foundation (ALFC) was established in July 2019 in Hong Kong as a charitable organization. This is one of the initiatives of Art of Nature Int'l to promote contemporary art with the aim of "establishing ourselves and reaching the talents". Art of Nature has gathered a group of established and emerging artists in Hong Kong, Mainland China and the world. Adhering to the concept of "taking from society and giving it back to society" and embracing the notion of "spreading love, kindness and beauty", and through effective integration of social resources, we are dedicated to three service areas of "Influential Outstanding Art", "Influential Women's Art" and "Influential Youth Art" by holding art exhibitions, academic seminars, art award ceremonies, youth scholarships, and art donations. We wish to promote Chinese culture, commend outstanding art contributors, enhance the status of women's art, and cultivate outstanding young artistic talents.

天趣藝術人生基金會（ALFC）是於 2019 年 7 月在香港正式成立的 NGO 慈善組織。這是繼 2008 年天趣國際藝術傳播機構繼 2011 年國際女性研究會成立以來，天趣國際再次以「己立立人，己達達人」為宗旨，從香港社會的長遠利益出發，積極推動當代藝術持續發展的又一善舉。

秉持著「取之於社會，用之於社會」的理念，懷抱「傳遞愛善美」的初心，天趣藝術人生基金會集結了一批本港、內地和國際知名的藝術精英，通過有效整合各界資源，積極回饋各類藝術公益事業，持續推動及完善「傑出藝術影響力」、「女性藝術影響力」、「青年藝術影響力」三大專項板塊，通過藝術策展、藝術頒獎禮、青年獎學金、藝術捐贈等公共慈善工作，弘揚中華文化、表彰卓越藝術貢獻者、提升女性藝術地位、培育優秀青年藝術人才。

① On 12 August, 2021, the Dr. Cissy Cheung, the Founder of Art Life Foundation, and Art of Nature curation team presented "The Path of Light – French Art Exhibition", bringing a feast of French artworks with the Former Chief Executive, Embassy representatives from various countries, and female artistsofficiating the opening ceremony.

2021 年 8 月 12 日，由天趣藝術人生基金會創始人張朱宇總策劃，天趣團隊執行的「光的足跡——法國藝術展」為大家帶來一場法國藝術盛宴，前特首、各國駐香港領事代表及香港女性藝術家代表出席展覽開幕式。

② On 12 August, 2021, Former Chief Executive Mrs. Carrie Lam attended the opening ceremony of the "The Path of Light – French Art Exhibition". Mrs. Lam also gave a speech to officiate the opening ceremony.

2021 年 8 月 12 日，前特首林鄭月娥出席並主持「光的足跡——法國藝術展」展覽現場，並於開幕式上致辭。

③ On 25 March, 2021, Mr. Kenneth Fok, member of the Chinese People's Political Consultative Conference, attended the opening ceremony of the exhibition curated by Dr. Cissy Cheung, the Founder of Art Life Foundation, and the Art of Nature curation team. The exhibition held at the Hong Kong City Hallgained widespread recognition among the art industry.

2021 年 3 月 25 日，政協委員霍啟剛出席由天趣藝術人生基金會創始人張朱宇總策劃，天趣團隊執行的展覽開幕式，本次展覽於香港大會堂舉辦，在業內收到諸多讚譽。

ABOUT HK ART OF NATURE INTERNATIONAL FEMALE ART RESEARCH SOCIETY
香港天趣國際女性藝術研究會簡介

Hong Kong Art of Nature International Female Art Research Society was founded in 2011 as a Hong Kongregistered non-profit organization. Our objective of uniting renowned female painters, sculptors, art administrators, curators, scholars, educators, collectors, as well as art enthusiasts interested in promoting contemporary female artworks across art-related fields. The Society aims to support female artists and help them achieve their full potential.

Since establishment, we have consolidated the structure, association memorandum and recruited extraordinary members. We are honored to invite numerous renowned artists, experts, theorists to guide and maintain our professions, as well as expanding thebeneficiaries. Through regular events such as exhibition visits, exchanges, seminars and sharing sessions etc., our society maintains a steady and mature growth,aiming for raising the influence of female arts in terms of academic, social and commercial values.

香港天趣國際女性藝術研究會於 2011 年登記成立，是一個研究、推廣女性藝術發展的非牟利機構。並藉此聯繫和團結知名的女性繪畫或雕塑藝術家、女性藝術行政人員或策展人、女性藝術學者或教育工作者，女性收藏家，以及學界內外任何有興趣於研討或參與女性藝術專業學問的人士。

自本會成立以來，逐步健全完善研究會章程、構架，努力吸納社會各界優秀會員。本會榮聘多位著名藝術家、學術專家、理論家以指導、保障研究會的學術性與專業性，同時吸納各界有意人士，充實會員，擴大受益群體。本會定期舉辦活動，如組織會員參觀展覽、交流心得、組織講座、分享成果等。通過悉心組織，本會日漸壯大、成熟，希望做更多有益的嘗試，為提升女性藝術的學術、社會、商業價值和影響力不斷努力。

① In November 2019, the exhibition scene of the "Blossom - Contemporary Female Art Exhibition" held in Shenzhen International Art Fair and the Influence of Female Art symposium.

2019 年 11 月「綻放 —— 當代女性藝術展」於深圳國際藝術博覽會開幕，圖為女性藝術影響力論壇現場。

② In October 2018, the 2nd "Because of Love" Contemporary Female Art Exhibition fully sponsored by the Hongkong Land was officiated in The Rotunda, Exchange Square, Central, Hong Kong, showcasing artworks by 16 outstanding female artists and two specially invited female artists – Liu Tung Mui and Minna Chan.

2018 年 10 月，由置地公司全力贊助的「大愛無疆」第二屆「憑著愛 —— 當代女性藝術展」於香港中環交易廣場開幕，展出來自香港 16 位優秀的女藝術家作品及同場展出兩位特殊展能女性藝術家廖東梅及陳曉妍作品。

③ During the 11th "Her Presence in Colours" in July 2014 in Mongolia, over 200 participating female artists photographed with guests in front of the Genghis Khan sculpture.

2014 年 7 月第十一屆「她‧色彩空間」蒙古展期間，成吉思汗雕塑前，參展的 200 多女性藝術家與嘉賓合影。

天趣女性藝術發展動態

ART OF NATURE FEMALE ART DEVELOPMENT

 「她力量──全球當代女性線上展」開啟全球征集，疫情兩年，展覽持續進行未停步

"Her Power - Global Contemporary Women's Art Online Exhibition" open call for global art collection continuously regardless two years pandemic

2021

AlFC 天趣藝術人生基金會成立，並成立「女性藝術影響力」板塊，助力女性藝術發展

Art Life Foundation was officially established. The "Influential Women's Art" sector is aiming to influence and help with female art development

2019

 「綻放──當代女性藝術展」及「綻放──女性藝術家的影響力」圓桌論壇在深圳舉辦

"Blossom - Contemporary Female Art Exhibition and Blossom - Influence of Female Art symposium " were held in Shenzhen

2019

 香港天趣國際女性藝術研究會成立

The Establishment of HK Art of Nature International Female Art Research Society

2011

 「大愛無疆──香港首屆國際女性當代藝術展」在香港大會堂低座舉辦

"Infinite Love -The 1st Hong Kong International Female Contemporary Art Exhibition" was held at the Exhibition Hall of Hong Kong City Hall

2015

「存在·她力量——國際女性當代藝術展」
於香港大會堂低座舉辦

2023

"Existence · Her Power – International Female
Contemporary Art Exhibition" held at the
Exhibition Hall of Hong Kong City Hall

 2023 「芊芊物華——香港女性藝術特展」於香
港天趣當代藝術館舉辦

"Flourishing Quintessence – Hong Kong
Female Art Exhibition" held at the Art of Nature
Contemporary Gallery Hong Kong

 2019 「綻放——當代女性藝術展」於香港天趣
當代藝術館舉辦

"Blossom - Contemporary Female Art
Exhibition" held at the Art of Nature
Contemporary Gallery Hong Kong

 2018 第二屆「大愛無疆」，即「憑著愛——當代女性
藝術展」在中環交易廣場中央大廳舉辦

The 2nd "Infinite Love", Known as "Because of Love
- Hong Kong International Female Contemporary Art
Exhibition" at The Rotunda, Exchange Square, Central,
Hong Kong

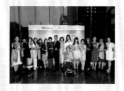

 2016 「請輕觸——女性當代藝術展」於香港天趣當代藝術館舉辦

"Soft Touch - Art of Nature Female Contemporary Art Exhibition"
held at the Art of Nature Contemporary Gallery Hong Kong

「存在·她力量」——國際女性當代藝術

Existence·Her power - International Female Contemporary Art

出 品 人：張朱宇	Producer : Cissy Cheung
總 編 輯：楊宜瑄	Chief Editor : Rochelle Yang
展覽總監：林秉瀚、Lulu Fong、林琛	Exhibition Director : Horace Lam, Lulu Fong, Lin Chen
策展統籌：湯石香	Exhibition Coordinator: Tang Shixiang
項目推廣：孫秀雲	Project Promoter : Sonia Sun
項目行政：吳靜雯	Project Administrator : Mandy Ng
項目公關：劉美寶	Public Relations : Mable Lau
策展助理：楊 明	Assistant Curator : Mandy Yang
項目助理：陳海英、嚴承熹、林秉韜	Project Assistant : Chen Haiying, Yim Xena, Bto Lam
視覺設計：楊宜瑄	Visual Design : Rochelle Yang
翻 譯：楊 明、林海菁	Translation : Mandy Yang, Lam Hoi Ching
文稿審核：潘嘉玲、林秉瀚、湯石香	Proofreader : Pan Jialing, Horace Lam, Tang Shixiang
美術編輯：李 珠	Designer : Li Zhu

出　　版：天趣藝術人生基金會有限公司　Publishing : Art Life Foundation Company Limited
　　　　　初文出版社有限公司　　　　　　　　　　　Manuscript Publishing Limited
印　　刷：陽光印刷製本廠　　　　　　　Printing : Sun Light Printing & Bookbinding Factory Ltd

發　　行：香港聯合書刊物流有限公司　Distributor : SUP Publishing Logistics (HK) Limited
地　　址：香港新界荃灣德士古道 220-248 號　Address : 16/F, Tsuen Wan Industrial Centre,
　　　　　荃灣工業中心 16 樓　　　　　　　　　　　220-248 Texaco Road, Tsuen Wan, NT, Hong Kong
電　　話：+852 2150 2100　　　　　　Tel : +852 2150 2100
傳　　真：+852 2407 3062　　　　　　Fax : +852 2407 3062

台灣地區總經銷：貿騰發賣股份有限公司　General Distributor in Taiwan : Modern Professional Distribution Co., Ltd
電　　話：+886 2 8227 5988　　　　　Tel : +886 2 8227 5988
傳　　真：+886 2 8227 5989　　　　　Fax : +886 2 8227 5989
網　　址：www.namode.com　　　　　Website : www.namode.com

新加坡地區總經銷：新文潮出版社私人有限公司　General Distributor in Singapore : Trendlit Publishing Private Limited
地　　址：71 Geylang Lorong 23, WPS618 (Level 6),　Address : 71 Geylang Lorong 23, WPS618 (Level 6), Singapore
　　　　　Singapore
郵　　編：388386　　　　　　　　　　Postal Code : 388386
電　　話：+65 8896 1946　　　　　　Tel : +65 8896 1946
電　　郵：contact@trendlitstore.com　　Email : contact@trendlitstore.com
版　　次：2023 年 3 月初版　　　　　First Edition : March 2023
定　　價：HK$ 138.00　NT$ 520.00　Price : HK $ 138.00　NT$ 520.00

ISBN：978-988-76891-2-6
Web：www.hkifars.com

她藝術 HER ART